IMAGES
of America

LAMAR COUNTY

D1500545

IMAGES
of America

LAMAR COUNTY

Barbara Woolbright Carruth

ARCADIA

Published by Arcadia Publishing,
an imprint of Tempus Publishing, Inc.
2 Cumberland Street
Charleston, SC 29401

Printed in Great Britain.

Library of Congress Catalog Card Number: 2001087612

For all general information contact Arcadia Publishing at:
Telephone 843-853-2070
Fax 843-853-0044
E-Mail sales@arcadiapublishing.com

For customer service and orders:
Toll-Free 1-888-313-2665

Visit us on the internet at http://www.arcadiapublishing.com

CONTENTS

ACKNOWLEDGMENTS

I have many people to thank for their help in making this book possible: Mrs. Peggy Adair, Mrs. Sheree Babb, Mrs. Faye Barnes, Mr. Peyton Bobo, Mrs. Lucille Bostick, Mrs. Betty Ruth Brock, Mr. and Mrs. Frank Buckley, Ms. Pat Buckley, Mr. Gene Cantrell, Mrs. Jean Carr, Mrs. Theresa Chandler, Mrs. Dorothy Cleveland, Mrs. Loree Christian, Mrs. Sammie Lee Elliott, Mrs. Mary Gilmer, Mrs. Virginia Gilmer, Mr. Marshall Guyton, Mr. and Mrs. Burt Hankins, Mrs. Lena Hawkins, Ms. Mary R. Hollis, Mr. Rex Hollis, Ms. Loretta King, Mrs. Kay Koonce, Mr. and Mrs. James Hill Maddox, Ms. Melissa McDaniel, Mrs. Dorothy Northington, Mrs. Evelyn Oakes, Mr. Billy Paul, Mrs. Gladys Pennington, Mrs. Nell Priddy, Mr. and Mrs. Junior Ray, Mrs. Marie Rowland, Mrs. Nannie South, Mrs. Sarah Jo Spearman, Mrs. Cecil Strawbridge, Mr. and Mrs. Charles Thomas, Mrs. Dianne Woods, Mrs. Virginia Woods, Mr. Sonny Clearman, Mrs. Clytee Jaggers, Mrs. Mildred Boyett, Mrs. Johnie Boyett, Mrs. Beulah Hill, Steve Lawhon, Mrs. Fay Lawhon, and Mrs. Patricia King. Joyce Jones and LuAnn Harden, with whom I work, have been most understanding when I needed to be away from the office, and I am grateful. If I have forgotten anyone, I assure you that I am most appreciative of your help.

I must mention my husband, Dewey Carruth; he was a great help in picking up and returning pictures. In 2000, he was elected to the Lamar County Commission District Two—so he had a big year—but he too is always willing to help.

Also, I want to thank my family—Barry, Jenny, Casey, Summer, Berney, Samantha, and Annia—who gave up "Sunday Dinner" for about six weeks so I could finish my project and help my sister take care of our mother. I can't fail to mention my sister, Jessie Woods, because she stayed with our mother more than her share, giving me time to work on the book.

It is wonderful to have spent my life in a county such as ours, with people who are willing to help others. All I had to do was call people and tell them what I was doing. It was during a busy holiday season but that didn't matter; they were willing to help. For their outpouring of help I am especially grateful. I collected over 700 pictures and could only include 231 in this book. It was a task—deciding what pictures to include—but I tried to represent the entire county the best that I could.

To the people at Arcadia Publishing, thank you for this opportunity. Ms. Katie White was very understanding when my mother broke her hip on Christmas Eve and I couldn't meet my deadline. I have not met her in person, but I believe she must have some ties to our Lamar County because she is so nice, cheerful, and eager to help. For that I am grateful.

After writing these acknowledgements, I feel so blessed. I hope you enjoy this book as much as I enjoyed putting it together. I had the wonderful opportunity to "travel back in time" with each picture. They are all special, and I'll never be the same.

INTRODUCTION

Lamar County is located in the northwest part of Alabama, covering 605 square miles in the upper coastal plains region. At one time, Lamar was part of Marion and Fayette Counties. The area is known to have been claimed by the Chickasaw tribe (although few Native-American relics have been found here), and to have been a part of that tribe's cession to the United States. The county line between Lamar and Pickens was known as the frontier between the Chickasaws and Choctaws.

It seems that early white settlers began coming to the county in the late 1700s, and came mostly from North Carolina, South Carolina, Georgia, and Tennessee. Few of the early settlers were slave holders. Most came traveling by covered wagon, bringing with them all of their possessions. Usually families that knew each other traveled together. The early settlers lived in log houses, and grew corn, cotton, cane, potatoes, and other vegetables. Settlement was slow due to the ruggedness of the country and the distance of markets.

Created by an act of legislature on February 4, 1867, the county was named Jones County, in honor of E.P. Jones of Fayette County. The territory was taken from Marion and Fayette Counties. In November of the same year, the county was abolished, and its territories returned to the counties from which it was taken. On October 8,1868, an act was approved creating a new county to be known as Sanford County—out of the same territory as that which Jones had occupied. Its boundaries were as follows: "Starting at the Mississippi line and following township line between eleven and twelve, to where said township line crosses the range line between the thirteenth and fourteenth range; and following said range line southward to the Marion and Fayette line, and thence along the same line southward to its crossing the Pickens County line, and thence along the Pickens County line westward to the Mississippi line, State line, and northward along said line to township line, between township eleven and twelve."

When Jones County was created in 1867, Pikeville, once the county seat of Marion County, was placed in Lamar County by mistake. Later the Alabama State Legislature had to change the boundary and gave Pikeville back to Marion County. This is why Lamar has a small offset in the northeastern boundary.

On February 8, 1877, the name was changed from Sanford to Lamar County and "all public property, rights and credits pertaining to said county of Sanford" were transferred to Lamar. The name change was to honor Lucius Qunintus Cincinnatus Lamar, who served as a senator for the state of Mississippi. The Georgia-born statesman moved to Mississippi around 1845, representing the state in Congress from 1856 to 1860. He was first a colonel and then a European diplomatic agent of the Confederacy during the War between the States, served Mississippi in Congress again from 1872 to1876, and became a U.S. senator in 1876. Lamar

moved the whole nation with the eloquence and magnanimity of his oration on the death of Charles Sumner in 1877, and it was then that the county's name was changed in his honor. Lamar was Grover Cleveland's secretary of the interior in 1887, and died in 1893, five years after elevation to the Supreme Court of the United States.

The county seat of Lamar is Vernon, and the topography of the county varies from rolling hills to almost mountainous areas with some superior valleys. The climate is mild in winter, and the drainage of the county is into the Tombigbee River. The nearest metropolitan areas are Birmingham, Alabama, and Memphis, Tennessee.

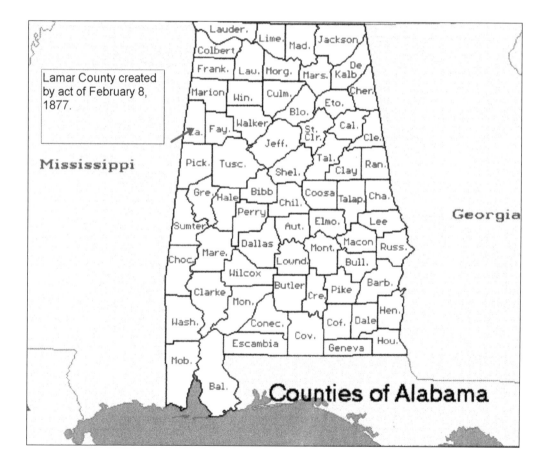

One
TOWNS AND OTHER PLACES

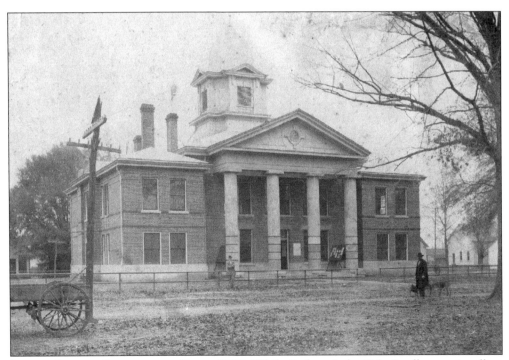

LAMAR COUNTY COURTHOUSE, BUILT 1909. While Probate Judge R.L. Bradley was in office, this courthouse was built in 1909. It was remodeled under Judge S.G. Johnson about 1948. The columns from the front were removed and the building was given a more "modern" look.

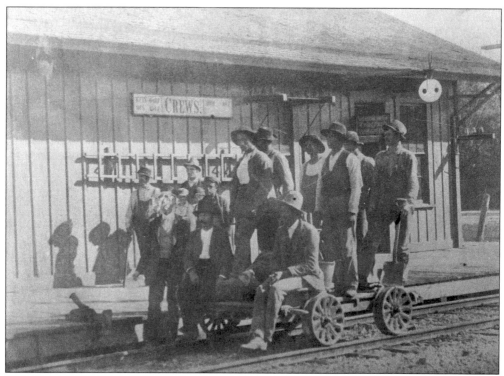

RAILROAD GANG AT CREWS. In the late 1800s and early 1900s, Crews was a busy place—due mainly to the railroad. A post office was established at Crews Depot on January 20, 1880. There was a college and it was well known until it burned. (Courtesy of Marshall Guyton.)

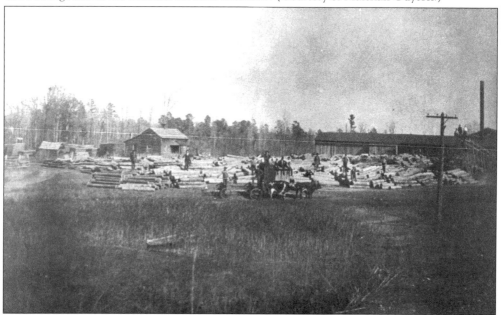

SAWMILL AT CREWS ABOUT 1890. Several hundred people lived in Crews in the early days. This sawmill was there, along with a boardinghouse, a general store, a fruit canning factory, and other establishments. (Courtesy of Marshall Guyton.)

DETROIT, ALABAMA, 1910. Located about 10 miles north of Sulligent, Detroit was first named Millville because there were so many mills in the area. The name was changed to Detroit around 1880 because of conflict with another town in Alabama named Millerville—the U.S. Postal Service was having trouble delivering the mail correctly. (Courtesy of Mr. and Mrs. Leon Kennedy.)

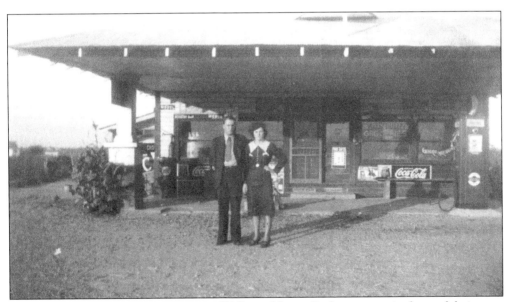

BUTLER'S STORE IN CROSSVILLE, 1938. Willis and Loree Butler are seen in front of their store in Crossville in 1938. She still lives in Crossville today and has given much to the community. (Courtesy of Loree Christian.)

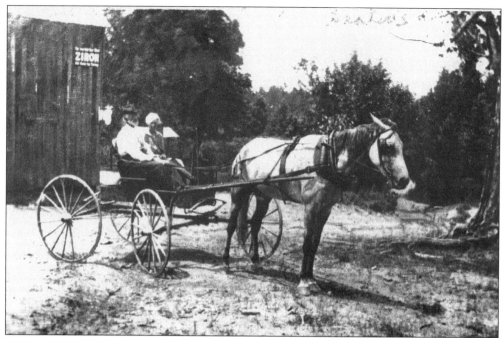

FINCH'S FIRST STORE. Tom Finch and his wife, Priscilla Harvey Hankins Finch, are seen in a wagon near their first store, which was located near Hunter Kennedy's place today. Priscilla enjoyed having a store near her home, and loved visiting with customers. (Courtesy of Mary Gilmer.)

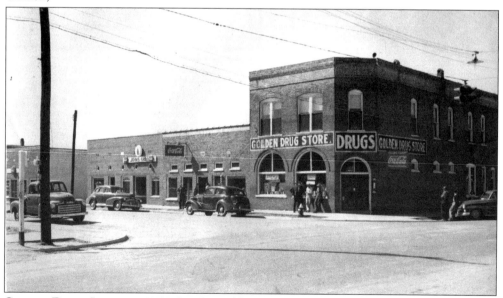

GOLDEN DRUG STORE C. 1950. Joe B. Golden was born October 28, 1894, to William and Elizabeth Golden in Millport. After being in the grocery business for seven years, serving in France during World War I, and working for Lee Miller and Son after the war, he became a registered pharmacist in 1920, graduating from the Barry O. Shiffett School of Pharmacy. He was in business for 50 years, and the store is a landmark in Millport. (Courtesy of Gene Cantrell.)

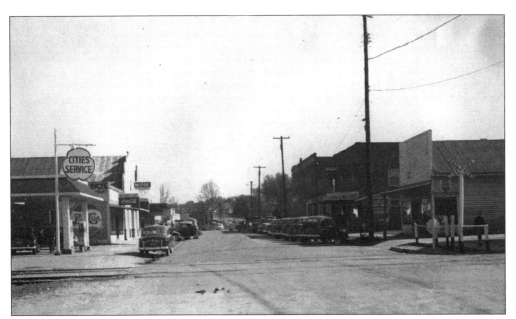

MILLPORT BUSINESS DISTRICT C. 1950. Millport was located near Luxapalila Creek, and was probably named for the many water-powered lumber, cotton, and grist mills in the area. The Millport Post Office was established on February 21, 1870, with Bartus McAdams serving as the first postmaster. The town was incorporated on February 28, 1887, and by 1900 business was thriving in Millport. (Courtesy of Gene Cantrell.)

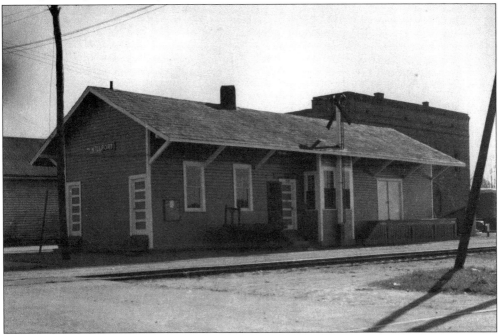

MILLPORT DEPOT C. 1950. This depot was not the first built at Millport—the first depot probably opened in 1887 as Georgia Pacific opened the railroad from Columbus, Mississippi, to Birmingham, Alabama. In 1894 it became Southern Railway Company, which took over operation of the Georgia and Alabama portions of the line. (Courtesy of Gene Cantrell.)

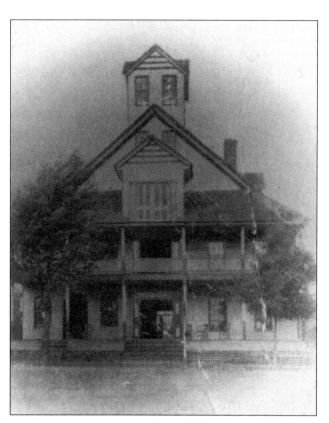

MILLPORT HOTEL, BUILT 1887. Henry W. Miller built the Millport Hotel and ran it for several years. Bob Biddle helped in the construction. Some of the lumber used in the hotel was sawed at the old water mill. W.K. Hull and his family ran the hotel for several years. The hotel was closed in 1930 when the proprietor, Mrs. Mary Williams Gunter, moved to Tuscaloosa. (Courtesy of L. Peyton Bobo.)

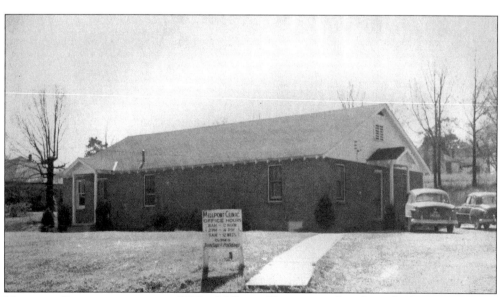

MILLPORT CLINIC IN THE EARLY 1950s. Millport Clinic opened its doors for business on June 15, 1949, with John R. Mize serving as the doctor. (Courtesy of Gene Cantrell.)

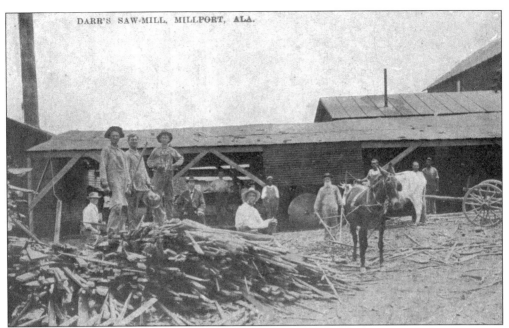

DARR'S SAWMILL IN MILLPORT. Pink Darr and Rufus Mathis at one time had a store, gin, sawmill, planer, and warehouse in Millport. The Darr and Mathis business operated from the late 1800s until about 1930, when they were forced to close because of the Depression. (Courtesy of L. Peyton Bobo.)

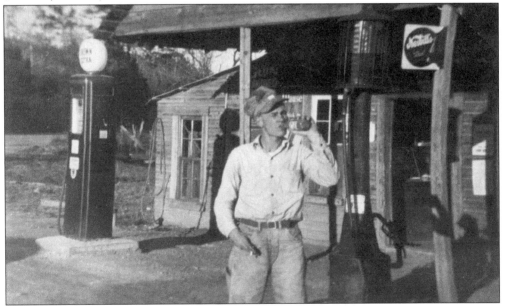

BURNETT'S STORE IN FAIRVIEW COMMUNITY. Bennie Burnett drinks a "Big Orange" in front of the store owned by his parents, Elmer and Artie Christian Burnett. The Burnetts had a kitchen and three bedrooms in the store building, and a schoolteacher boarded with them. Elmer later served as Lamar County Commissioner District 3. When he died while in office, Mrs. Burnett finished his term. Fairview Community is located southeast of Sulligent. (Courtesy of Nannie South.)

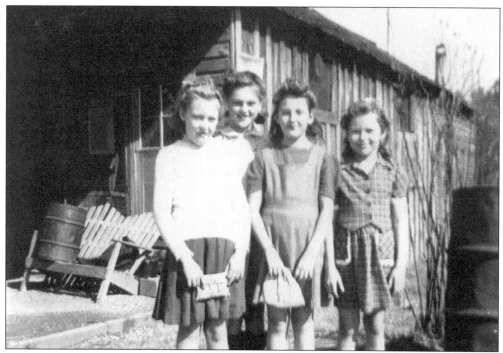

FOUR BEAUTIFUL GIRLS IN FRONT OF BURNETT'S STORE. Pictured from left to right are Virginia Christian, Jeanette Stanford, Juanita Burnett, and Joan Gilmer. The store was bought by Juanita Burnett's parents in 1939—Murray Gosa had started the business. Some of the families that lived in this community were Burnett, Christian, and Sizemore. (Courtesy of Nannie South.)

MADDOX GRIST MILL IN SHILOH. James C. Maddox was a good businessman; he had a grist mill and managed a farm in the Shiloh Community, southeast of Sulligent. He later moved to Sulligent. This photo was taken in the early 1900s at the grist mill. James C. was the son of William W. Maddox, one of the early settlers of the county. (Courtesy of James Hill Maddox.)

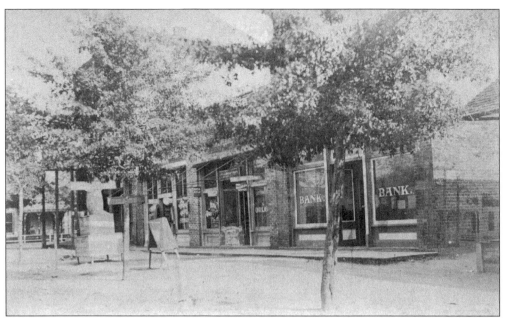

EARLY SCENE IN SULLIGENT. Sulligent was first called Elliott, in honor of the chief engineer of the Kansas City-Memphis-Birmingham Railroad. It was renamed one month later in honor of Sullivan, the superintendent of the railroad, and in honor of Sargeant, the passenger agent of the railroad. The town was incorporated October 1887. (Courtesy of Nell Priddy.)

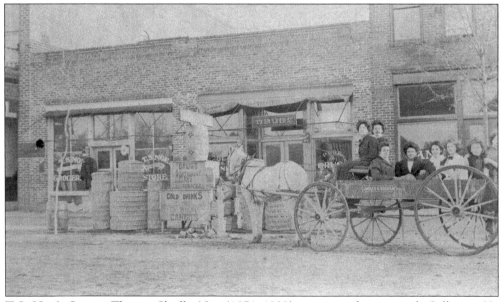

T.S. NOE'S STORE. Thomas Shaffer Noe (1871–1929) was a merchant in early Sulligent. He operated a general store, a hotel, and even a movie theater—a silent picture show where his daughter Elsie Claire played accompanying piano—all located on the town square of Sulligent. It is said that he would give free crackers to customers who bought sardines for lunch. (Courtesy of Nell Priddy.)

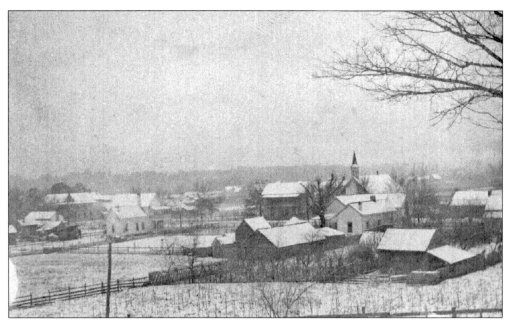

RESIDENTIAL SECTION IN SULLIGENT, 1910. In the right back of this photo you can see the steeple of the First Baptist Church in Sulligent. (Courtesy of Nell Priddy.)

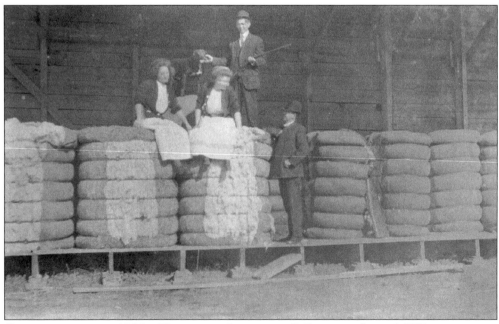

COTTON IN THE MID-1890S. The primary business in Sulligent in the mid-1890s was cotton, with over 2,500 bales ginned each year and shipped by way of the railroad. This photo was taken at the gin in Sulligent c. 1910. At one time the Sulligent Cotton Oil Company was known as the largest cotton gin under one roof. (Courtesy of Nell Priddy.)

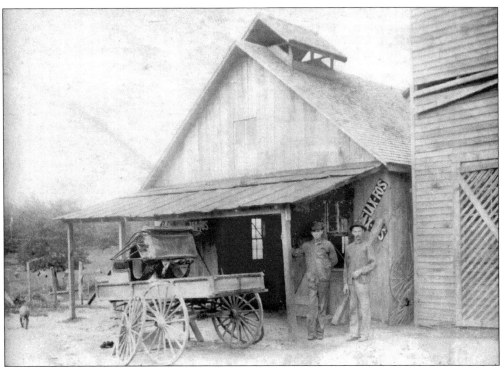

LIVERY STABLE IN SULLIGENT. Around 1907 Walter Maddox came to Sulligent and bought a train ticket to Texas. As he heard the train approaching the depot, he decided against leaving and turned in his ticket. That same day he bought a livery stable that he and his brothers—John Maddox and Ernest Maddox—operated until 1916, when the business became a car dealership. (Courtesy of James Hill Maddox.)

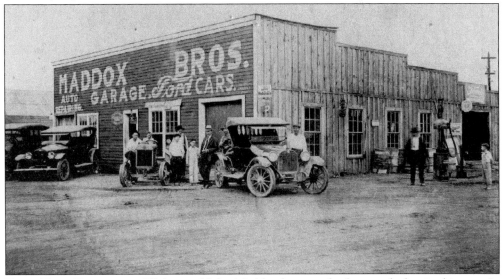

EARLY FORD DEALERSHIP. Walter and John Maddox became the first car dealers in this area. In 1916 the Ford agency was the Kennedy-Maddox Motor Company in Sulligent. Later it was operated as Maddox Brothers, and then it was operated by their sons, James Hill and Brooks Maddox. (Courtesy of James Hill Maddox.)

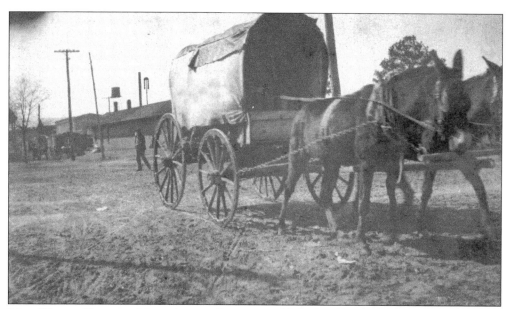

MAIL WAGON DELIVERS MAIL. A post office was established at Cansler in the 1800s, which was later changed to Sulligent on December 7, 1887. In 1880 the post office was located in the business of R.J. Redden & Company. (Courtesy Nell Priddy.)

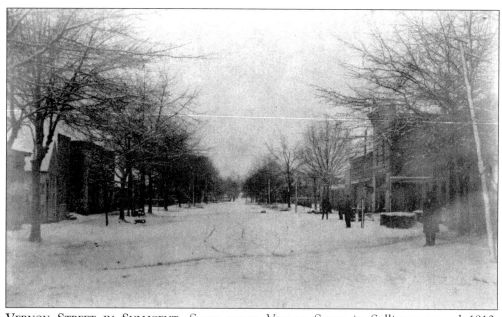

VERNON STREET IN SULLIGENT. Snow covers Vernon Street in Sulligent around 1910. (Courtesy of Nell Priddy.)

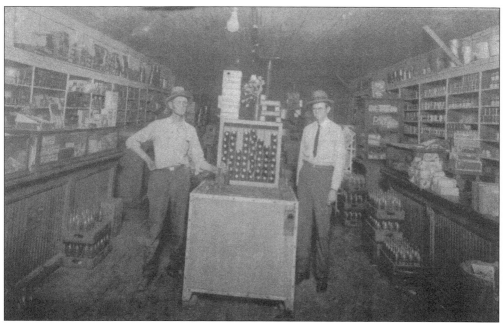

METCALFE'S STORE, EARLY 1900S. Seen from left to right are Will C. Evans, the owner of the building, and Ed Metcalfe, the store owner. Will C. Evans was Lamar County circuit clerk in 1911, lived in Sulligent, and owned the house where Mrs. Mildred Boyett lives today. (Courtesy of Gail Evans and Kay Evans.)

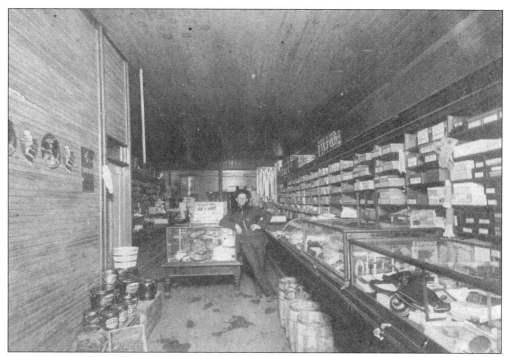

STUCKEY'S FIRST STORE. James Henry "Jim" Stuckey opened his first store in 1909—he started his business with $300. This photo was made about 1910. (Courtesy of Virginia Woods.)

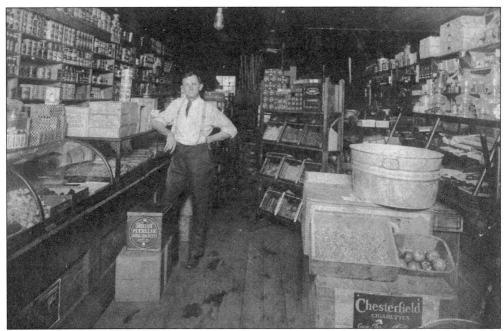

Stuckey's Store c. 1920. J.H. "Jim" Stuckey was in business for 50 years. He married Alice Elvira Reeves in 1910 and bought a house in Sulligent. Stuckey retired from the grocery business at age 73. (Courtesy of Virginia Woods.)

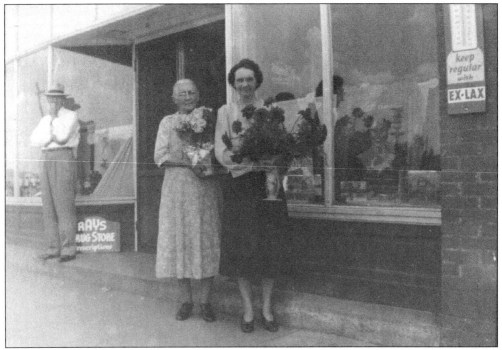

In front of Ray's Drug Store. Seen from left to right are J.M. Ray, Ila Brown, and Lena Ray in May 1948. Ray's Drug Store was located on Front Street in Sulligent. (Courtesy of Gladys Pennington.)

SNOW ON FRONT STREET, 1949. Gladys Mansell Pennington is pictured in front of Ray's Store on Front Street in Sulligent. Mrs. Pennington worked for J.M. Ray. (Courtesy of Gladys Pennington.)

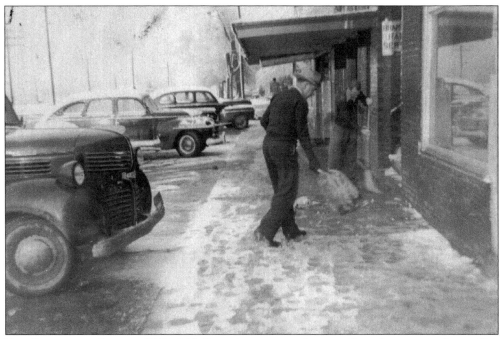

RAY SWEEPS THE STREET, 1949. J.M. Ray tries to sweep the snow from the street in front of his store in 1949. (Courtesy of Gladys Pennington.)

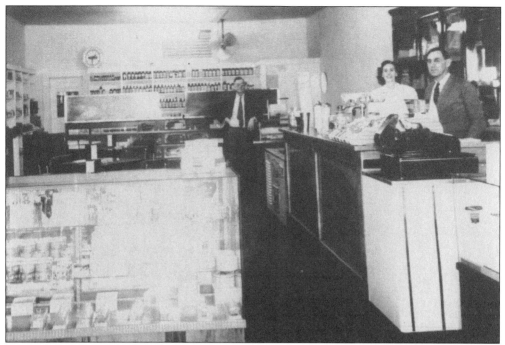

RAY'S DRUG STORE. Seen from left to right are Mr. Herrod, pharmacist, Gladys Pennington, and J.M. Ray, owner. When the citizens in Sulligent joined together to build Sulligent Clinic, the doctors would not agree to come to town until there was a drugstore with a registered pharmacist, so J.M. Ray established Ray's Drug Store. This photo was made in 1948. (Courtesy of Gladys Pennington.)

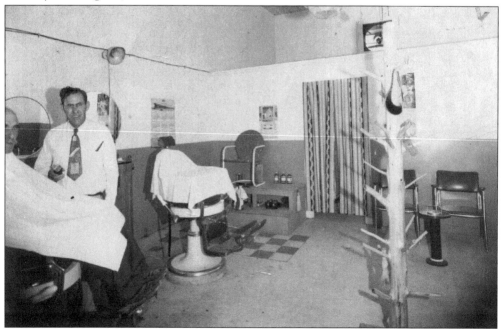

BARBER SHOP. Getting a haircut in Sulligent is W.W. Mansell and standing by the chair is Judge Frye, the barber. (Courtesy of Gladys Pennington.)

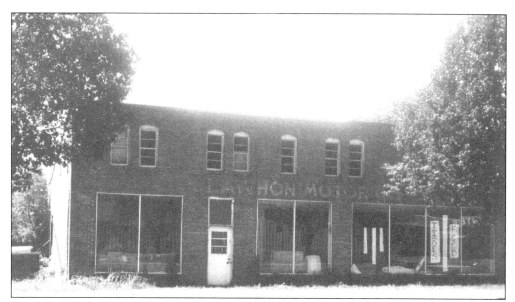

LAWHON MOTOR COMPANY DEALER FOR CHRYSLER. Lawhon Motor Company was located on Gattman Street in Sulligent and the building still stands today. In 1935 E.C. Lawhon Sr. became a dealer for the Chrysler Corporation and began taking orders for automobiles. In 1946, he built the Lawhon Motor Company. Bricks for the building were transported from Columbus, Mississippi, by E.C. Jr. and his brother Coleman. (Courtesy of Fay Lawhon.)

E.C. LAWHON JR. AND SON. Pictured is E.C. Lawhon Jr and his son Steven in front of the Lawhon Motor Company in Sulligent. The Lawhon family moved to Bibb County, Alabama, in 1820 from North Carolina. They moved to Marion County, Alabama, in 1839, and to Lamar County about 1900. (Courtesy of Steve Lawhon.)

REST AND RELAXATION. Enjoying a break from daily activities are E.C. Lawhon Sr. and Pearl Shackelford Lawhon. They are both sitting on the rock, far right. (Courtesy of Fay Lawhon.)

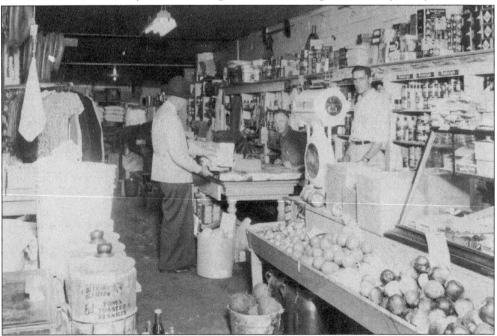

PRICE GROCERY STORE, EARLY 1940s. Pictured in this photo, from left to right, are an unidentified customer, Vonnie Price (seated), and J.D. Ford (standing). V.M. Price was born in Lawrence Beat in Lamar County. He married Hattie Noe on October 8, 1929. Mr. Price was a World War I veteran and owned a rolling store in Beaverton before moving to Sulligent, where he had a dry goods and grocery store in an old wooden building. (Courtesy of Dorothy Cleveland.)

SULLIGENT DEPOT. The Frisco Railroad was constructed in 1887 and was called the Kansas City, Memphis and Birmingham Railroad. The depot was once a lively spot, with locals leaving to visit relatives or people coming to the county on business. In 1905 you could ride the train for less than half fare to all points in Indian and Oklahoma Territories—one way $6.50 or round trip $10. (Courtesy W.W. Ogden II.)

IN FRONT OF BUCKLEY'S STORE, 1941. Pictured from left to right are Frank Buckley, Henry Guyton, and Roy Buckelew, with the Frisco Depot in the background. Frank Buckley's grandfather, M.L. Buckley, came to Sulligent in 1913 and opened a hardware store on Front Street. He ran this store until his death in 1930. (Courtesy of Frank Buckley.)

SNOW IN SULLIGENT, 1949. Floyd Yarbrough, a pharmacist at Ray's Drugstore, is seen in this photo with the Sulligent Depot in the background. (Courtesy of Gladys Pennington.)

OLDEST WOODMAN OF THE WORLD MEMBERS IN LAMAR COUNTY. Seen from left to right are Felix Sizemore, R. Brown, Ed Metcalfe, Roy Norton, and James H. Stuckey. Woodman of the World was a society established in Omaha, Nebraska, in 1890. (Courtesy of Virginia S. Woods.)

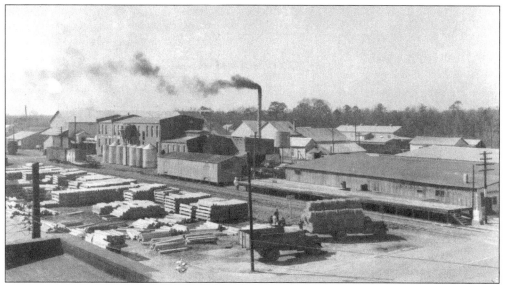

THE SULLIGENT COTTON OIL COMPANY, C. 1948–1950. The Ogden Family moved to Sulligent in 1905 and established the Interstate Milling Company at Ogden's Mill on Bogue Creek; later the Sulligent Cotton Oil Company was incorporated. (Courtesy of W.W. Ogden II.)

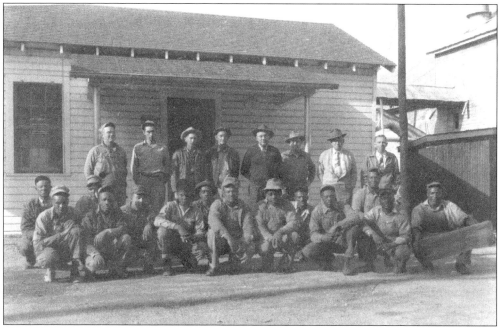

SULLIGENT COTTON OIL COMPANY WORKERS, C. 1950. The workers pictured, from left to right, are (front row) Les Glown, Booker T. Washington, Charley Bankhead, Willie Lee Jones, Walter Davis, John Wesley Summers, Hewitt H. Cannon, Dock Kidd, Jim Ogden, Connie Nolen, Perry Ogden, and Frank Johnson Evans; (middle row) Walter Carter and Will E. Jones; (back row) Sam Pat Evans, Howard Dobbins, Veto Woodham, Newt Holliday, Fred Ogden, Elmer Odom, Victor C. Paul, and Henry Guyton. (Courtesy W.W. Ogden II.)

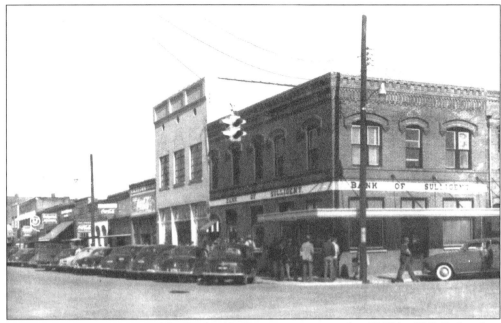

BANK OF SULLIGENT, 1950S. The Bank of Sulligent was organized in 1905 by W.P.G. Smith, a stockbroker in Birmingham with a group of investors. The bank opened early in 1906 with Mr. Smith as president, but W.W. Ogden bought controlling interest and took the helm a few months later. (Courtesy of W.W. Ogden II.)

RAY'S MULE BARN. Wood Ray owned Ray's Mule Barn in Sulligent for many years and he was well known as the "Mule Trader." Ray's Mule Barn stands today and is owned by Wood's son, Junior Ray. (Courtesy of Junior Ray.)

30

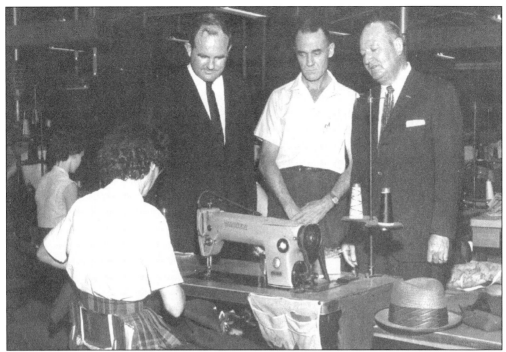

CURTIS CONNER GIVES GOVERNOR A TOUR. Alabama Governor John Patterson visits the McCoy Manufacturing Company in Sulligent. Curtis Conner, plant manager, gives a tour of the facility. McCoy Manufacturing, owned by Coy Glenn of Amory, Mississippi, opened in 1953, providing work for many residents of the county. (Courtesy of Patricia King.)

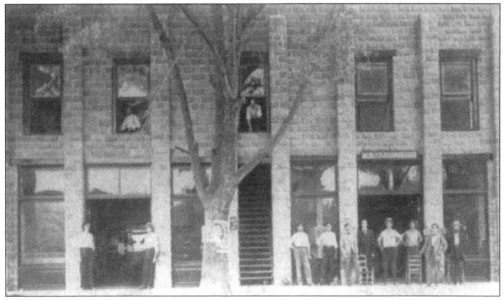

CLEARMAN'S STORE IN VERNON. Pictured in this photo (from left to right) are M.D. Clearman, Worth B. Clearman, seven unidentified, and E.N. Clearman on the end. Dr. Key, a dentist, and Wilson Kelly, a lawyer, had offices upstairs above the store. This dry goods business was established 1899 and is still in business today. (Courtesy of Sonny Clearman.)

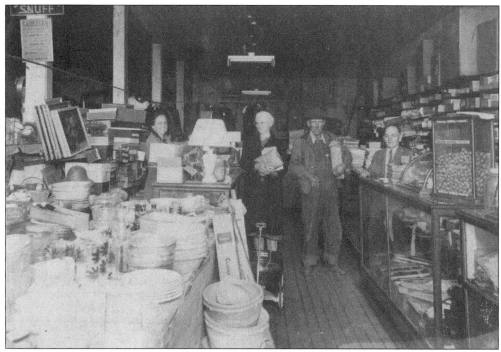

INSIDE CLEARMAN'S STORE. Seen from left to right are Beuma Nichols Clearman, Mrs. Wiley Kemp, Wiley Kemp, and W.B. Clearman. (Courtesy of Sonny Clearman.)

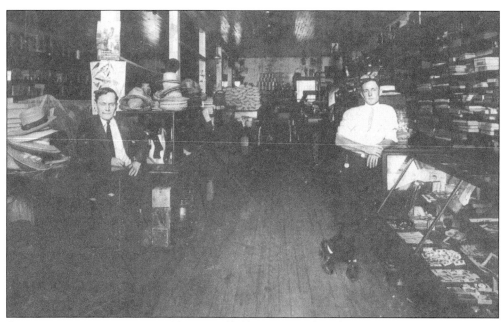

CLEARMAN BROTHERS. W.B. Clearman (left) is pictured with Newman Clearman. Sonny Clearman, W.B. Clearman's son, runs the store today, and it looks much the same as it did in this picture. (Courtesy of Sonny Clearman.)

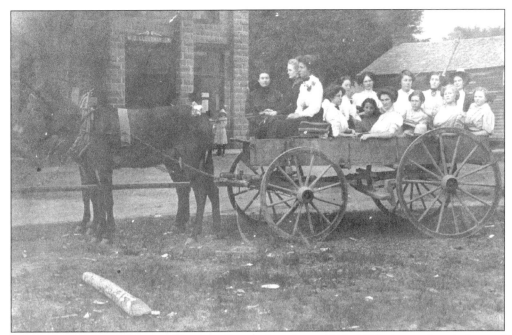

WAGON OF YOUNG LADIES IN VERNON. Pictured in this *c.* 1911–1912 photo taken in front of Clearman's store are, from left to right, (front) Maude Henderson, Parrie Lacy, and Ellie Wilkerson; (middle) Adine Pennington, Ruth Herndon, Flandie Morton, Mary Young, Zada Morton, and Ruby Morton; (back) Euna Rolls Lacy, Mattie Lou Henson, Coy Box, Irene Pennington, and Rose Green. (Courtesy of Sonny Clearman.)

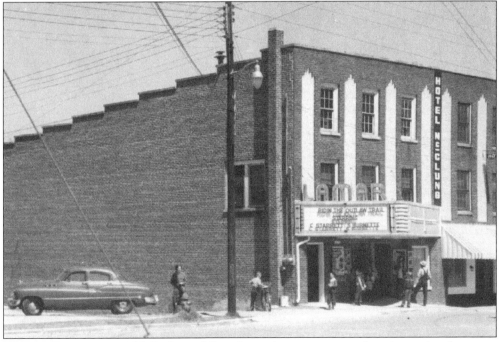

VERNON THEATER C. 1955. Friday and Saturday night movies were a favorite pastime for many. (Courtesy of Gene Cantrell.)

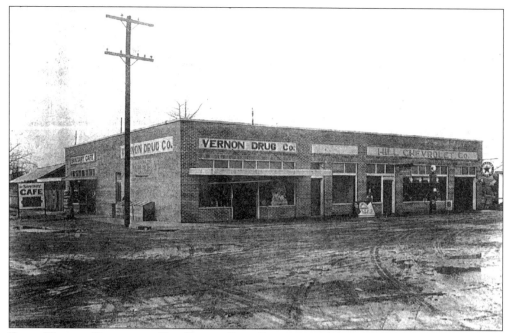

EARLY VERNON BUSINESSES. THE Vernon Drug Company and the Hill Chevrolet Company are seen here. (Courtesy of Kay Koonce, owner Tommy Dean Chandler.)

BANK OF VERNON. T.S. Jones (left) is pictured with Myrtle Hankins. They were the only employees of the bank when this photo was taken in 1920.

IN FRONT OF LAMAR COUNTY COURTHOUSE. Pictured here in 1920, from left to right, are Newman Clearman, Orpha Elizabeth Black Hankins, Morris Livingston, and Sallie Cobb Milner. (Courtesy of Burt Hankins.)

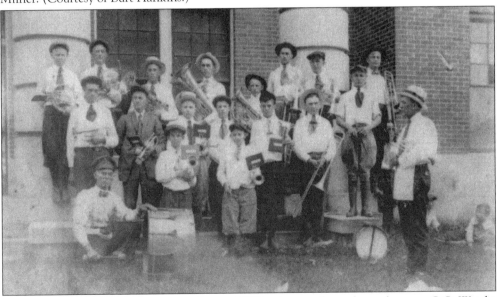

GOLD STAR BAND ON COURTHOUSE STEPS, 1930s. Among those shown here are C.C. Wright (director), E.E. Allen, T.A. Cole, Everette Houston, Banks Brock, and Sidney Guyton; (drums) William Houston, Jay Armstrong, Glenn Collins, Woods Redus, Robert Mattox, and Joe Price Redus; (trombones) Lloyd J. Seay, Clovis Gault, Plato Johnson, and Roy Strickland; (baritones) Thomas Tims and William Young; (tuba) Edgar Duke. (Courtesy of Kay Koonce; owner of picture, Cloyce Hayes.)

LOST CREEK FAMILY. Lost Creek Community is located about five miles northwest of Sulligent. From left to right are Claude King, Clay King, Sarah King, Wash King, Clyde King, and Clarence King. Claude, Clarence, and Clyde were all in the logging and saw mill business in the 1940s.

SUNDAY DINNER CROWD. Sarah Evans King of the Lost Creek Community never knew how many to cook for on Sundays. Her husband, Wash King, would invite folks from church to come home with them for "Sunday Dinner." Pictured is a group of relatives and friends that gathered at the Kings for one of those dinners. Wash and Sarah are on the third row from the left.

Two

DOCTORS, LAWYERS, POLITICIANS, AND REGULAR PEOPLE

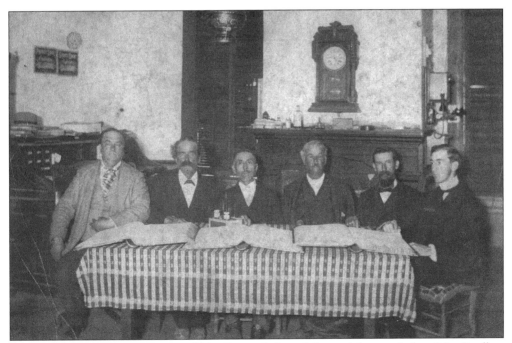

LAMAR COUNTY COMMISSION, 1900. Pictured from left to right are Judge R.L. Bradley, William Burton Hankins, Benjamin Winstead Evans, Jim A McCollum, W.L. Beasley, and J.T. Maddox, clerk.

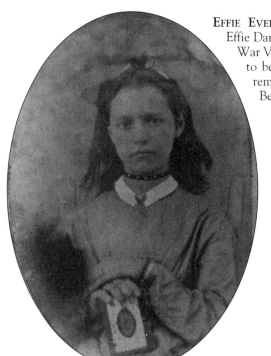

EFFIE EVELYN DARNELL ABERNATHY (1860–1955). Effie Darnell married Richard M. Abernathy, a Civil War Veteran, and they had ten children. She lived to be 95 years old. Their son Frank Abernathy remained on the family farm. (Courtesy of Beulah A. Hill.)

MARY PATRICIA ADAIR, 1955. At the suggestion of Mrs. Virginia S. Mayes, Trish's picture was sent in to the Channel 6 Television Station in Birmingham for a beauty contest the station was promoting. Trish placed in the top 15 and her parents, Mr. and Mrs. Felix Adair, were very proud. (Courtesy of Peggy Adair.)

Leon Buckley, World War I. Leon Buckley (left) is the father of Frank and Corky Buckley, who live in Sulligent today. (Courtesy of Frank Buckley.)

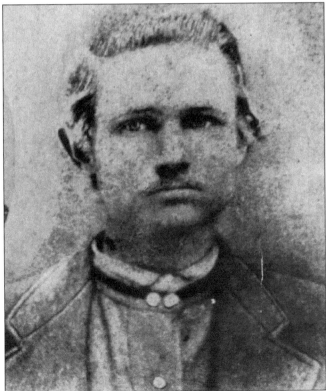

Rube Burrow, Train Robber. Rube Burrow robbed his first train on December 1, 1886—in broad daylight—with the help of his brother, Jim Burrow, and two cowboys. It was a passenger train on the Ft. Worth-Denver Railroad at Bellevue, Texas. Rube was alleged to have killed a rural postmaster, Moses J. Graves, in Lamar County, Alabama, concerning a package addressed to an "alias" in the county.

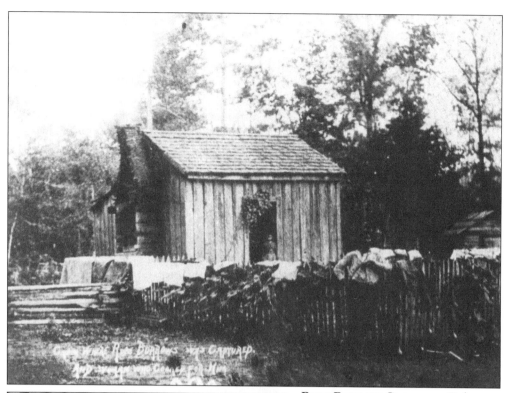

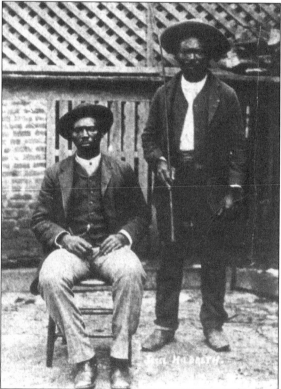

RUBE BURROW CAPTURED. Rube Burrow was captured in Marengo County, Alabama in George Ford's cabin. Few bandits in the south or southwest were so widely known from 1886 to 1890 as Rube. He would climb aboard the engine, usually at night, as it was pulling away from a station, and force the engineer, at gunpoint, to stop the express car on solid ground, leaving the passenger car stranded on a trestle.

RUBE BURROW CARRIED TO JAIL. Rube Burrow was captured by these two black men, Jesse Hildreth and Frank Marshall, with the help of two white planters, John McDuffie and Jeff Carter, at George Ford's house in the Myrtlewood Community of Marengo County, Alabama, on December 7, 1890. They carried him to jail—with Rube entertaining them all the way with funny stories.

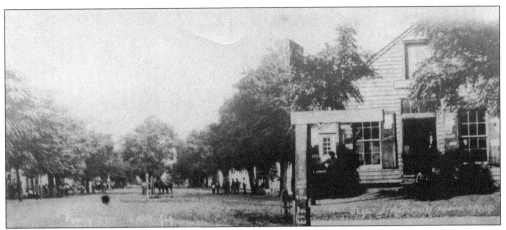

BURROW IN LINDEN, ALABAMA. Rube Burrow was taken to jail in Linden, where he escaped, locked two guards in his cell, took another guard as a shield, and went across the street to Glass' Store looking for Jeff Carter. He wanted to get back money that Carter had taken from him. When Carter came outside, he and Rube exchanged gunfire. Afterwards, Rube was dead in the street and Carter was wounded.

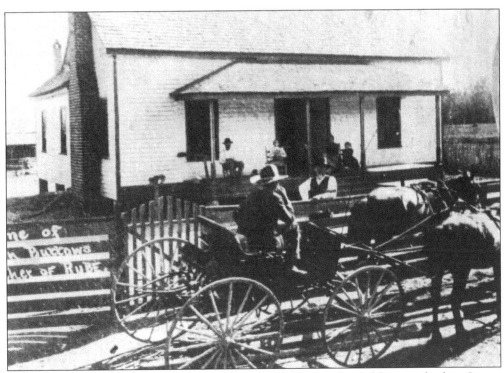

RUBE BURROW'S FATHER'S HOUSE. Rube Burrow's body was shipped by train back to Lamar County. It was reported that on a stop in Birmingham thousands viewed the corpse and people snatched buttons from his coat, cut hair from his head, and even his boots were carried away. Rube's father, Allen Burrow, met the train in Sulligent. It was reported that the train attendants threw the coffin at his feet. Allen Burrow carried his son back to his home community near Vernon and buried him in Fellowship Cemetery.

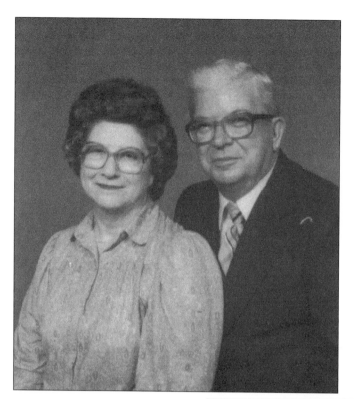

RAYMOND AND LUCILLE BOSTICK. Raymond and Lucille Bostick opened their first business in 1945 in Vernon. The population of Vernon was 720 at the time, and all the businesses were located around the courthouse square. Mr. Bostick also served as the first voted-in mayor of Vernon, from 1952 to 1960. (Courtesy of Lucille Bostick.)

JOSEPHINE LILLIAN WOODS BOX (1888–1976). Mrs. Box, daughter of Dr. Thomas Bailey Woods and Jane Elizabeth McCrary Woods, graduated from the West Point Female Institute in West Point, Mississippi, and married Dr. W.L. Box. Mrs. Box went with the doctor on calls, in all kinds of weather, and at all hours. They supplied food and clothing as well as medicine to families who were unable to pay. (Courtesy of Sarah Jo Spearman.)

WILLIAM LYLES BOX (1882–1958).
Dr. Box was born in Bedford
Community near Vernon. While
trying to save enough money to go to
medical school, he taught school at
Bedford. Eventually he talked a
Columbus, Mississippi banker into
loaning him money for medical
school. In 1906, he graduated in a
suit of clothes that cost him $6.
(Courtesy of Sarah Jo Spearman.)

**BILLY BURKE AND AZELL COLLIER BOX,
1931.** On March 23, 1931, Billy Burke Box
and Katherine Azell Collier were married at
the Third Presbyterian Church in
Birmingham. Billy Burke was the son of Dr.
W.L. and Josie Box of the Bedford
Community near Vernon. Azell was the
daughter of Mose Collier and Sarah Ann
Nelson. (Courtesy of Sarah Jo Spearman.)

43

CAL BROWN, 1946. This picture was taken in April 1946 in back of Ray's store. Cal Brown worked at JM. Ray & Son's store in Sulligent. He was a kind, gentle man and well liked by everyone who knew him. (Courtesy of Gladys Pennington).

DROLAN CHANDLER WORLD WAR II. Drolan Chandler served in the U.S. Army during World War II as a machine tail gunner. He was part of the Bataan Death March in the Philippines, where he was a prisoner of war for 42 months. Drolan saw the flash when the bomb was dropped on Nagaski. (Courtesy of Drolan Chandler.)

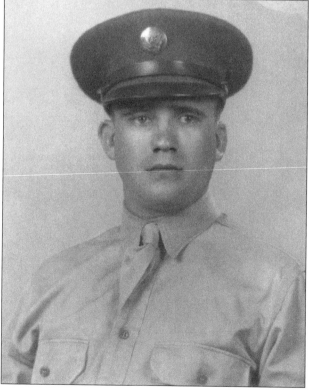

CADE CHRISTIAN. Cade Christian left Alabama and went to Texas. He was accused of burning a church. He was ambushed, returning from the trial where he was proven not guilty, and shot several times. His wife was with him, and he died in her arms. They were both on horse back. Cade was a brother to John Christian. (Courtesy of Loree Christian.)

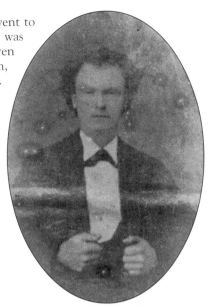

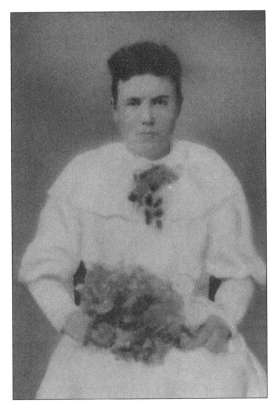

SARAH ANN NELSON COLLIER, 1910. This picture was made April 10, 1910, on the day she married Beverly Mose Collier. Sarah was the daughter of Alexander Barney and Nancy Catherine Thompson Nelson. Beverly Mose worked as a warehouse manager in Sulligent and Sarah was a housewife. (Courtesy of Sarah Jo Spearman.)

DR. J.T. DUNN C. 1910. Dr. J.T. Dunn was a dentist in Sulligent in the early 1900s. (Courtesy of Nell Priddy.)

JOHNNIE F. ELLIOTT, 1944. Johnnie F. Elliott went to Pearl Harbor as a civil servant to help clean up after the bombing in 1941. He is the husband of Sammie McDaniel Elliott and lives near Vernon today. (Courtesy of Sammie Elliott.)

JOHN THOMPSON GILMER (1832–1892). Thompson Gilmer married Eliza Woods in 1858. Eliza died in 1860 leaving a young baby, Mary Amanda. In 1864 he married Frances Elvira Woods, the sister of his first wife. Frances died in 1870; he then married Judy Malinda Hankins—niece of his first two wives—in 1872. (Courtesy of Virginia Woods Gilmer and Mary Kennedy Gilmer.)

JUDY HANKINS GILMER C. 1925. Judy married Thompson Gilmer when she was very young. Often she played an Irish harp, singing old ballads. One of her favorites was "Barbara Allen." Judy loved roses and one fragrant clear, red rose has been passed through the Gilmer family as "Grandma's Rose." (Courtesy of Virginia Gilmer.)

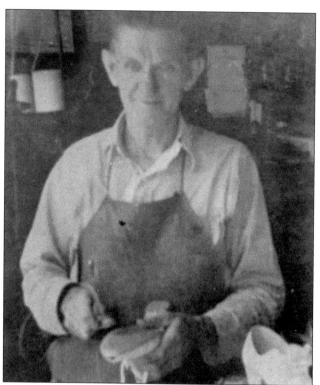

CHARLES EDGAR GRAHAM C. 1955. Charles Graham is seen at work in his shoe shop in Millport. He owned and operated Graham's Shoe Shop from 1927 until 1963; he also wrote poetry. (Courtesy of L. Peyton Bobo.)

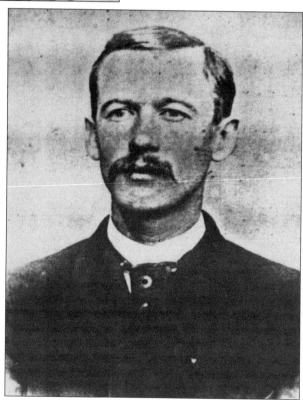

JOHN S. GUYTON (1842–1917). John S. "Squire" Guyton was born in the small community of Shiloh. He was one of the early mayors of the town of Sulligent. It is said that he owned land from Vernon Street in Sulligent to Gattman, Mississippi. (Courtesy of Peggy Adair.)

JOHN FRANKLIN HANKINS (1831–1861). John Franklin Hankins died in Richmond, Virginia, from typhoid fever while serving in the Civil War. He was the son of Stephen Hankins, the husband of Sarah Angeline Woods, and the father of Sarah "Franky" Hankins. (Courtesy of Mary Kennedy Gilmer, Frank Buckley, and Virginia Woods Gilmer.)

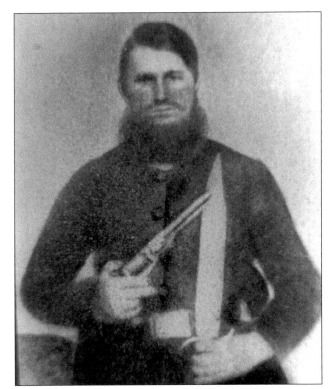

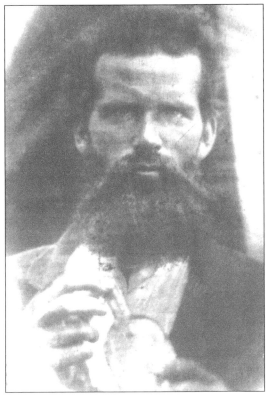

STEPHEN HANKINS (1805–1870). Steven Hankins was a planter and landowner in the Union Chapel area. He had seven sons and four sons-in-law who served in the Confederate Army. Three sons, John, Isom and Thomas Benton, were casualties, along with three sons-in-law. (Courtesy of Frank Buckley.)

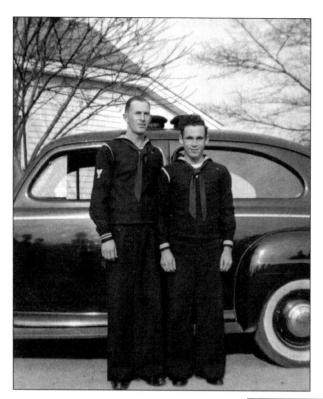

TWO SAILORS IN 1944. Kelcy Hankins and his nephew, Eugene Jones, are pictured in 1944. Alma Hankins, sister of Kelcy, married Tommy Jones. (Courtesy of Loree Christian.)

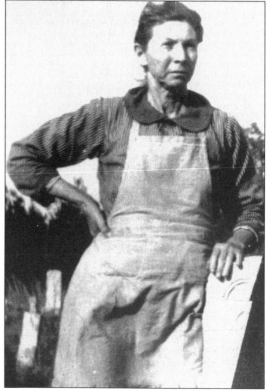

SARAH ELIZABETH HOLLIS CARR. Cleaning the graveyard at Friendship South Cemetery is Sarah Elizabeth "Lizzie" Hollis Carr, getting ready for decoration day. Lizzie was born 1891, and married William Henry Carr in 1905. She was a descendant of early Lamar County pioneers Red Dan Hollis and Mary Salvage, also Rev. James Riley Baker and Sara C. Ingram. (Courtesy of Jean Carr.)

WILLIAM PERRY HUGHEY. On January 30, 1880, a document written by William Perry "Bill" Hughey announced that he would open a school in July and would offer the following classes: "Orthography, Reading, Penmanship, Geography, Arithmetic, English, Grammar, Rhetoric, and Algebra." The school was located in the Beaverton Community. (Courtesy of Rex Hollis and Mary Ruth Hollis.)

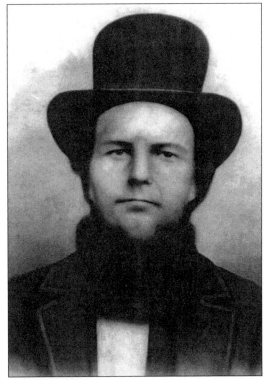

JOHN EVANS AND ELIZABETH VIRGINIA BOMAN JACKSON (1925). Evans Jackson and Elizabeth "Bett" Boman were married after the Civil War. He was a Confederate soldier. They were both members of First Baptist Church in Sulligent before 1925. (Courtesy of Mary Gilmer.)

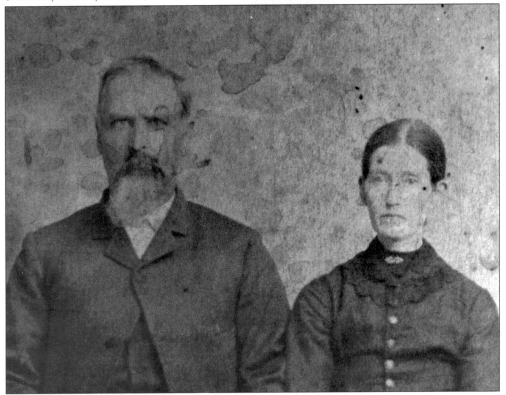

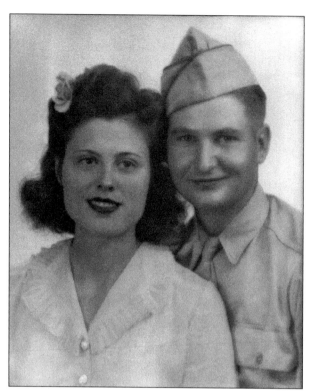

MOMAN AND CLYTEE JAGGERS, 1945. Moman Jaggers (1920–1998) married Clytee Turman, and she was a wonderful helpmate to him. Moman was a lifelong resident of the Lost Creek Community. He was a veteran of World War II, and after returning home from the service he was a sawmiller and farmer. (Courtesy of Clytee Jaggers.)

CLAUDE KIDD, 1946. J.M. Ray & Son's Store in Sulligent was a favorite place for Claude Kidd to hang out. There was always something going on in the store as locals would stop by. (Courtesy of Gladys Pennington.)

LEROY HOLLIS KENNEDY (1864–1896). Leroy Hollis Kennedy was an early elected sheriff of Lamar County, but he died shortly before his term of office began. He was married to Nancy Molloy. (Courtesy of Mary Kennedy Gilmer.)

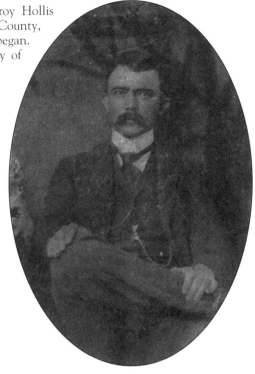

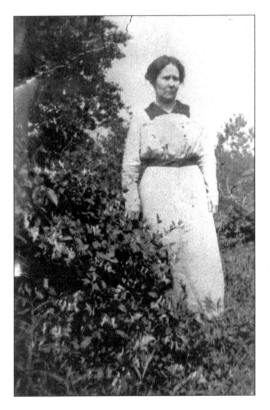

NANCY MOLLY KENNEDY (1863–1922). Nancy Molloy married Leroy Hollis Kennedy, who was elected sheriff and died an untimely death. She was an unusual businesswoman for her time, as records in the Lamar County Courthouse show her business transactions. The Molloys were Methodist and deeply religious. (Courtesy of Mary Kennedy Gilmer.)

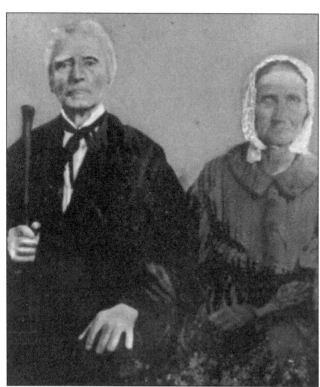

BURWELL AND SARAH MARCHBANKS, 1851. In 1850 Burwell and Sarah Harwood Marchbanks came to Fayette County (now Lamar). They built their home on the west side of Yellow Creek and lived their remaining days in the Shiloh Community. He founded the Shiloh Baptist Church in 1851 and he and his large family were faithful members through the years. Many outstanding citizens of Lamar County have descended from Burwell and Sarah Marchbanks. (Courtesy of Virginia Woods Gilmer.)

R.A. "RUFUS" MATHIS. Mathis was in business with Pink Darr in the Millport area. They had a saw mill, planer mill, and gin. He was known as a kindhearted man. (Courtesy of L. Peyton Bobo.)

THOMAS NOE C. 1933. Thomas Noe married Mary Jane Loggains, and they made their home in the Pine Springs Community north of Sulligent. He was a farmer. (Courtesy of Mildred Boyett.)

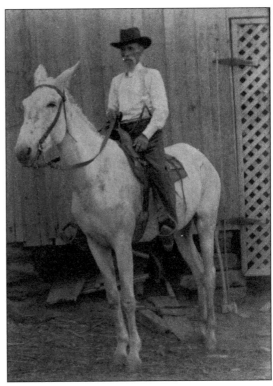

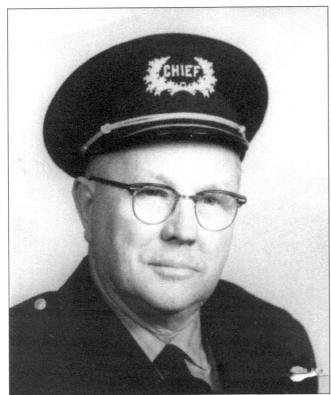

ROBERT LAKE NOLEN C. 1950. "Lake" Nolen was police chief of Sulligent. He took the job in 1930, serving for 48 years. (Courtesy of Sheree Babb.)

RENZO FRANKLIN ODOM (1875–1963).
Charles P. Odom (left) is pictured with
Renzo Franklin Odom whose business
became known as R.F. Odom and Son
when the latter was old enough to work.
They were in the general merchandise,
cotton-buying, lumber, and real estate
business. Charlie Odom was in the New
Orleans Cotton Exchange and the
Chicago Board of Trade. They were the
only business in the area to have a ticker
tape. (Courtesy of L. Peyton Bobo.)

ROBERT CARROLL PAUL. Robert
Carroll Paul (left) is pictured with
Lillie Pearl Byrd Paul. Her father
was Lucian David Byrd, born in
1861 near Detroit. He was a charter
member of First Baptist Church in
Sulligent. Robert Carroll served as
Lamar County Commissioner and
was known as "Sug." (Courtesy of
Billy C. Paul.)

JAMES G. PENNINGTON, 1943. James G. Pennington gave his life in the line of duty September 27, 1943, in the North African Area. He was the husband of Gladys Mansell Pennington and the son of Willie and Ellie Wheeler Pennington. (Courtesy of Gladys M. Pennington.)

SILAS FILMORE PENNINGTON (1852–1895). S.F. Pennington was elected sheriff of Lamar County in 1884, and was serving as mayor of Sulligent when he died in 1895. He was killed as a heavy plank that had been left on one of the railroad cars projected out, striking him on the forehead as he passed by and killing him. (Courtesy of Peggy Adair.)

57

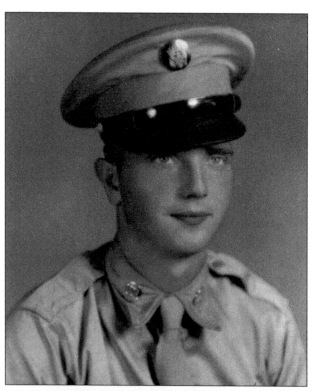

BOBBY PENNINGTON C. 1952.
William Bobby Pennington, the
son of Lakon Lamar and Josie
Gladys Hollis Pennington, served
in the Army during the Korean
War, 1952–1954. (Courtesy of
Gladys M. Pennington.)

**BOBBY AND JOHNNIE MANSELL
PENNINGTON IN THE 1950S.**
William Bobby Pennington and
Johnnie Mansell were married
May 26, 1956. Johnnie's parents
were Richard and Wilda Eastman
Mansell. (Courtesy of Gladys M.
Pennington.)

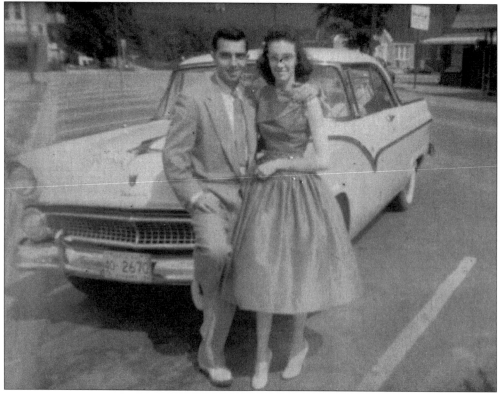

JUDGE CECIL STRAWBRIDGE AND MRS. STRAWBRIDGE. Judge Cecil Strawbridge served as circuit judge of the 24th Judicial Circuit—which was composed of Lamar, Fayette, and Pickens Counties—for four six-year terms. He retired at age 70. Judge Strawbridge married Sarah Autense Rector on May 11, 1941, and she was a helpmate to him throughout his career. (Courtesy of Autense Strawbridge.)

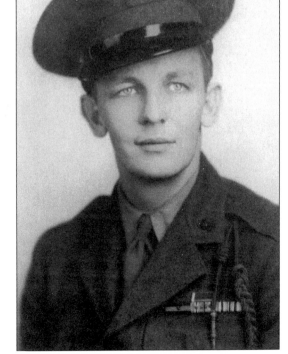

EVERETT STUCKEY, 1942. Everett Stuckey was inducted into the Marion Corps on January 2, 1942. He trained at Paris Island, South Carolina, and was wounded at Cape Glouchester, New Britain. He was discharged at Pensacola, Florida, serving 42 months. (Courtesy of Virginia S. Woods.)

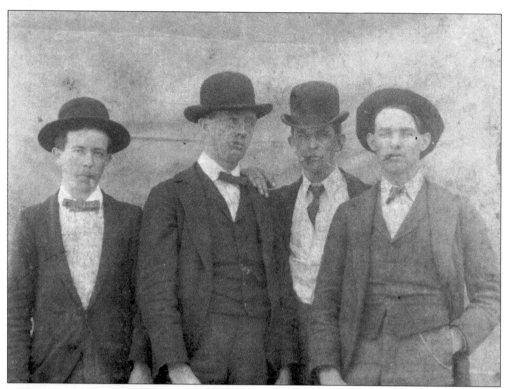

HILL STRICKLAND AND FRIENDS, 1899.
Harkney Hill Strickland is the second from
the left in this photo from January 1899.
Hill Strickland married Ada Hodo; they
went to Birmingham on their honeymoon
and stayed at the old Morris Hotel.
(Courtesy of L. Peyton Bobo.)

CHARLES THOMAS, 1942. Charles Thomas
was discharged at Fort Dix, New Jersey, in
1945. New trucks could not be found in the
Lamar County area at that time. While he
was stationed in New Jersey, Charles found
trucks for sale, bought five when
discharged, and he and his brothers drove
the trucks to Vernon. Ralph and Clifton
Thomas each bought one of the trucks from
him. (Courtesy of Charles Thomas.)

THE FATHER OF THE THOMAS BROTHERS. Anderson Thomas and his sons, Ralph, James, Charles, and Clifton Thomas, hauled logs by wagon, using oxen or mules, to various lumber companies. Charles worked with his father until 1937, then went into business for himself. Hauling logs first, then coal, he began buying feed products and hauling them back to Vernon for resale in 1940. Ralph Thomas built a large trucking firm. (Courtesy of Charles Thomas.)

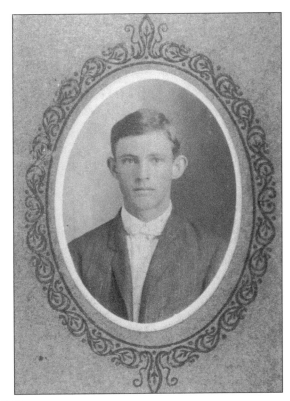

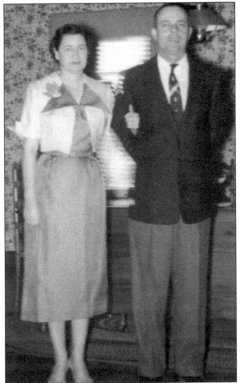

CHARLES AND AILEEN THOMAS. While Charles Thomas was serving his tour of duty with the Army, Aileen and his brother Clifton continued to run his trucking business. Starting with one truck in 1937, this firm grew into one of the oldest and largest trucking firms in the Vernon area. Under the management of its principal owner, their son Elmer, the company is currently operating in 48 states and Canada (Courtesy of Charles Thomas.)

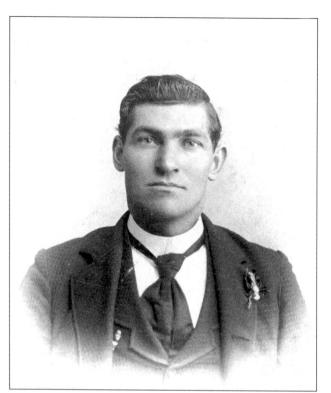

DR. BERRY EDLEY TURNER, 1897. Dr. Turner practiced medicine from 1897 until 1913 in the Sunnyside Community. He was the son of Edley and Martha Scott Turner, who came to Lamar County in 1858 or 1859. (Courtesy of Betty Ruth Brock.)

W.W. WALDROP(1886–1964). W.W. Waldrop built the first electric plant in Millport, served one term in the state legislature, served 20 years on the Lamar Democratic Executive Committee, served 19 years on the local school board, and served 28 years on the Millport Town Council. (Courtesy of L. Peyton Bobo.)

THOMAS MOORE WOODS C. 1895. Thomas Moore Woods was born in 1844, and he was only 16 years old when he enlisted in the Company K 16th Alabama Regiment of the Confederate Army. He was mustered in under the huge oak tree near the John Hollis place on Military Road. After the war he returned home and married Hannah Mansfield Nolen. (Courtesy of Virginia Gilmer.)

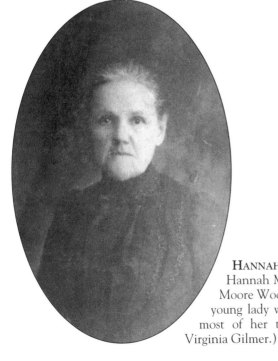

HANNAH MANSFIELD NOLEN WOODS C. 1895. Hannah Mansfield "Mannie" Nolen married Thomas Moore Woods after the Civil War. Mannie was a pretty young lady with many talents. A homebody, she spent most of her time caring for her family. (Courtesy of Virginia Gilmer.)

THOMAS CLARENCE WOODS (1905–1990). Thomas Clarence Woods was born in the Shiloh Community to Alice Adaline and John Wells Woods. He married Virginia Pauline Stuckey in 1935, and served 16 years as Lamar County Commissioner .His wife Virginia still lives at their homeplace. (Courtesy of Virginia Woods.)

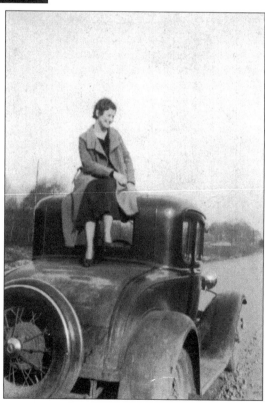

VIRGINIA STUCKEY WOODS C. 1935. Virginia Stuckey is pictured in her "courting days" sitting on top of Thomas Clarence Woods' car—they later married. (Courtesy of Virginia Woods.)

Three

MULES, TRAINS, AND AUTOMOBILES

A 1927 MODEL T. Included in this photo of a 1927 Model T at Millport is Ernest Loe. (Courtesy of L. Peyton Bobo.)

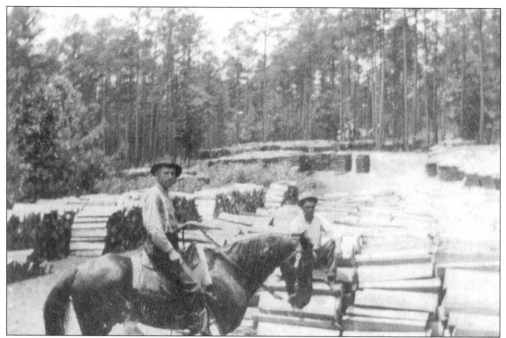

STAVE MILL YARD 1918. W.W. King is shown here at his stave yard on his horse. Some of the men had their families live in tents while they worked at the stave mill.

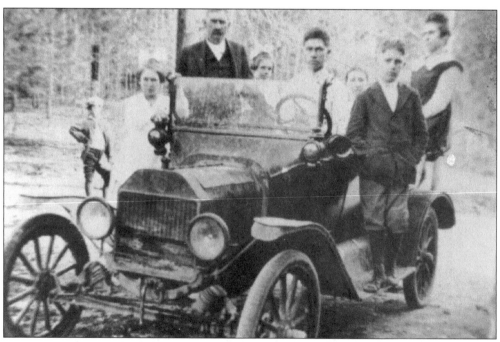

BLAYLOCK FAMILY. The William Hasten "Bill" and Eliza Ann "Lila" Evans Blaylock family lived in the Shiloh North or Lost Creek Community. Pictured from left to right are Flora, William Hasten, Clara Bell, Escar (behind wheel), Eliza Ann, Nancy Redona, and Raymond Guffy (standing on "running board").

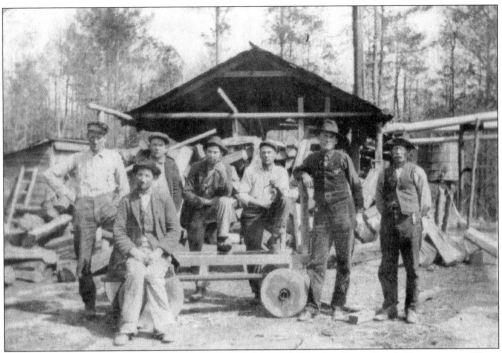

STAVE MILL, 1918. W.W. King's stave mill crew was located in Lost Creek Community; King is the second person from the right. Staves were cut to make tubs, buckets, and also barrels for whiskey.

KING CHILDREN READY FOR A BUGGY RIDE. Pictured from left to right are Pearl (holding baby Carl), Lula Bell, and Connie King. The parents are Willie Washington and Sarah Evans King.

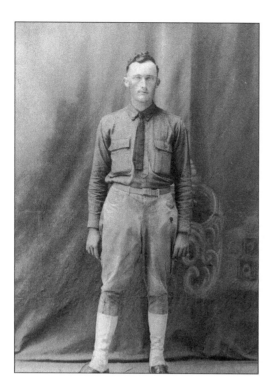

TOMMIE RUSHTON ADAIR'S WORLD WAR I PICTURE. He married Vera Jane Wright on December 24, 1921. He was from the Vernon area. (Courtesy of Peggy Adair.)

GILMER DAIRY FARM IN THE EARLY 1950S. Caley Smith is seen in the early days of Gilmer Dairy. Gray Gilmer had left the family farm and was living in Kingsport, Tennessee, working with an insurance company as an industrial engineer. When his parents died, Gray return to the farm in 1951 and started Gilmer's Dairy, which is still in operation and in the family today. (Courtesy of Mary Gilmer.)

MACK HOLLIS MOLASSES MILL. Martha Ann McDaniel is seen making molasses at Mack Hollis Molasses Mill. (Courtesy of Kay Koonce.)

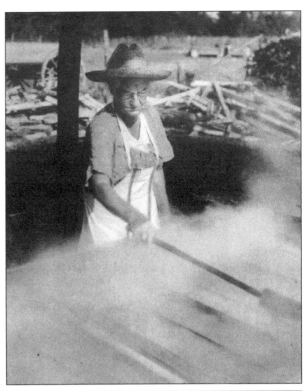

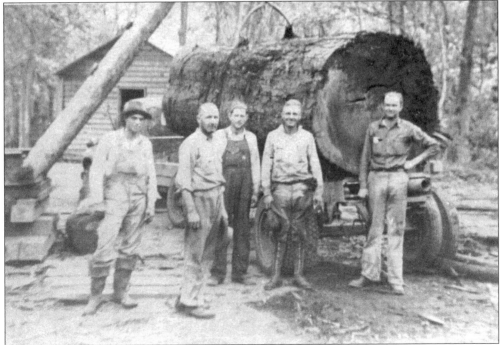

LOGGING IN THE BUTTAHATCHIE BOTTOM. Seen from left to right are unidentified, Clyde King, unidentified, Claude King, and Mike Gilliland. A large tree was believed to be logged out of the river bottom near Sulligent.

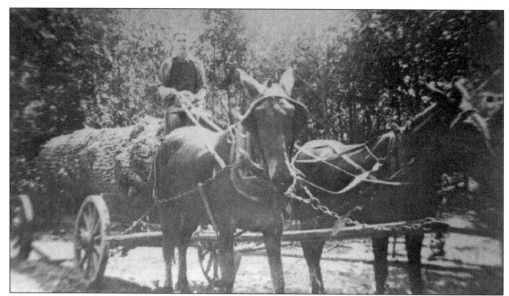

"SKIDDIN" LOGS. Jack Woolbright came to Lamar County when Kentucky Lumber Company was here, helping log the Buttahatchee Bottom near Sulligent. He remembered a cypress tree cut out of the bottom—it had over 5,000 board feet in it. The tree was about 6 feet through at the butt. They had to weld two cross-cut saws together to cut it down.

FRIENDS FOREVER. Friends living in the Lost Creek Community about 1929 were, from left to right, Avist Blaylock, Opal Rushing, Verdo Wright, Grace Rushing, and Lyde Paul. (Courtesy of Avist Carden.)

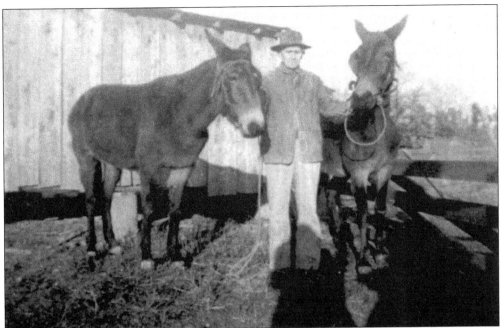

SIMEON CHANDLER AND MULES. Simeon Allen Chandler and his mules are pictured about 1940. Simeon Allen married Ada Maybelle Hankins, and had the following children: Almus Allen, Arlie Brooks, Myrtle Lucille, Clovis Hamilton, and Curtis Arnold. (Courtesy of Kay Koonce.)

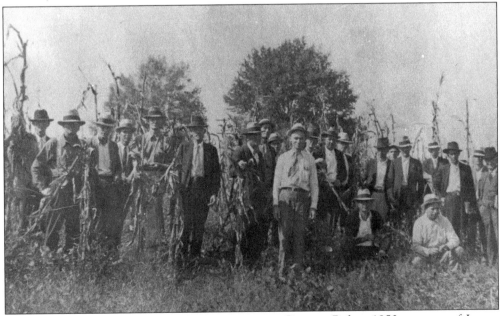

PRODUCTION AND MARKETING ADMINISTRATION GROUP. Before 1950, a group of Lamar County farmers served as community committeemen of the Production and Marketing Administration (PMA), which was created to oversee the administration of farm programs in each county. W.W. King is third from the left and Howard Rowland is fifth from the left (squatting). Howard Rowland was the office manager.

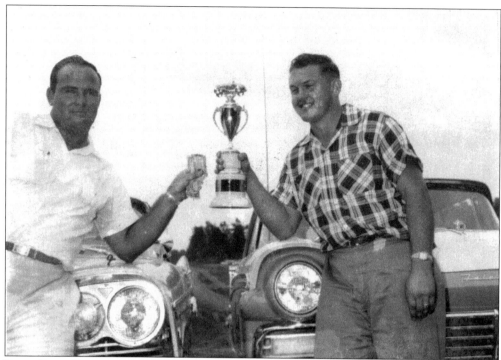

DRAG RACE WINNERS. Billy Joe Crawford and Warren Jordan are pictured after winning a drag race in the 1950s. They are both from Vernon. (Courtesy of Sheree Babb.)

OUT FOR A RIDE. Pearl Shackelford Lawhon (1889–1972), wife of E.C. Lawhon Sr., is believed to be the person on the horse on the left. (Courtesy of Fay Lawhon.)

Four

SCHOOLS AND CHURCHES

BEAVERTON CLASS 1949. Pictured from left to right are Doris Cannon, unidentified, Mary Lou Crumbley, unidentified, Leo Harney, unidentified, Leon Gann, Mrs. Lena Ray, Faye Cole, and Monta Trentham. (Courtesy Faye C. Barnes.)

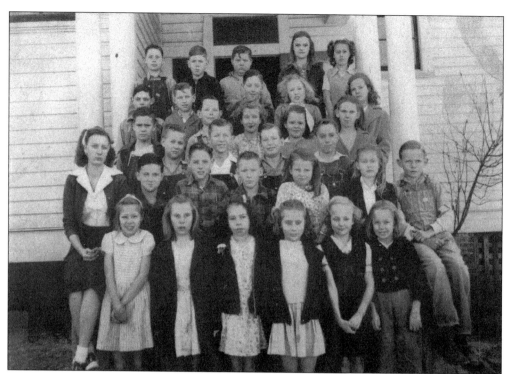

BEAVERTON SCHOOL, 1946–1947. The students pictured here, from left to right, are (first row) Jo Ann Trentham, Pollie Robinson, Mary Sue Frye, Imogene Sizemore, Loretta Woods, and Frankie Sizemore; (second row) Willie Mae Sizemore, teacher, Clyde Gibbs, Tom Weeks, Kenneth White, Viola Robinson, Sue Alexander, Elberton Mixon; (third row) Garvin Hollis, Cudell Cantrell, Lloyd Palmer, Billy Blaylock, and Junior Cantrell; (fourth row) Herman Barnes, Halen Robinson, Thermon Cannon, Loventrice Robertson, Doris Cannon, and Marie Robertson; (fifth row) Dennis Barnes, Josephine Black, and Maxine Alexander; (sixth row) Leon Gann, Blanton Carrouth, Bobby Barnes, Louise Crumley, and Faye Cole. (Courtesy of Faye C. Barnes.)

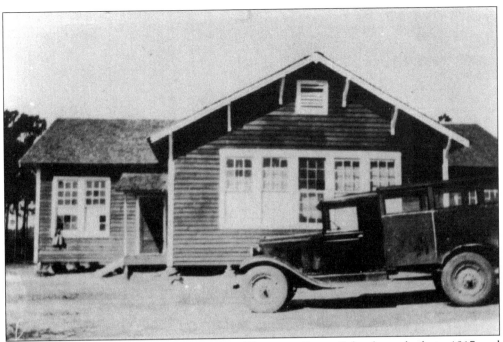

BLOOMING GROVE SCHOOL BEFORE 1933. Blooming Grove School was built in 1917 and burned in 1933. Willis Butler's school bus is seen parked in front. (Courtesy of Loree Christian.)

BLOOMING GROVE BALL TEAM IN 1930. Shown here from left to right are Nina McDonald, Valeria Jenkins, Pattie Tate, Flora Jenkins, Olete Smith, and Parrie Tate. (Courtesy of Loree Christian.)

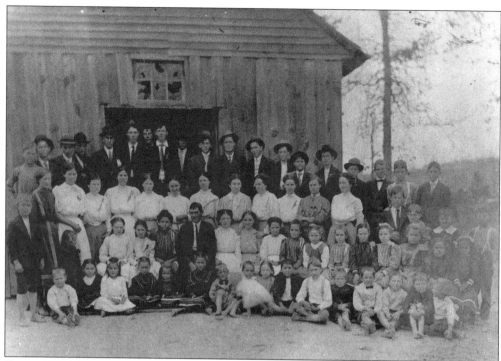

CONTRARY HILL SCHOOL. The students in this photograph, from left to right, are (first row) Lloyd Wright, Lou Mitchell, Elsie Russell, Hettie Mitchell, Velma Hall, Evie Mitchell, Clyde McDaniel, Morris Glasgow, Loyd Russell, Mattie Wheeler, William Wallace, Ike Moore, Austin Robertson, Leonard Russell, ? Harris, Hezzie Wheeler, and Lester Wright; (second row) Myrt Wheeler, Eunice McDaniel, Maybelle Wheeler, Myrtle Wallace, Dora Hall, Jess Glasgow, Carrie Wheeler, Hattie Wright, Elma Russell, Frances Hall, Floy Mitchell, Lelia Robertson, Edna Mae McDaniel, Fannie Bell McDaniel, Drucella Hall; (third row) Ed Hall, Pliny Jones, Dally Gault, Hettie Glasgow, Velma Gault, Ellie Wheeler, Lula Wright, Lelia Wheeler, Maudie Glasgow, Naomi Glasgow, Millie Mitchell, Mary Jones, Donnie Glasgow, Curless McDaniel, Morgan Jones, Roy McDaniel, and Lin Wright; (fourth row) Edgar McDaniel, Murry Mitchell, Ed Jones, Larcus Johnson, Ernest Nolen, Jim Wright, Jess Wheeler, John Wright, Ed Glasgow, ? Glasgow, Jeff Gault, Robert Nolen, Bradley McDaniel, Harvey Mitchell, Claude Wright, and Davis Nolen. (Courtesy of Sammie Lee. Elliott.)

ELEMENTARY TEACHERS. Pictured in the early 1950s are the following Vernon Elementary teachers, from left to right: (front) Blondie Crawford and Adine Lee; (back) Dessie Newman, Fay Smith, Annie C. Smith, Ordelia McGee, Betty Ruth Brook, Theresa Woods, and Rue Hayes. (Courtesy of Theresa Chandler.)

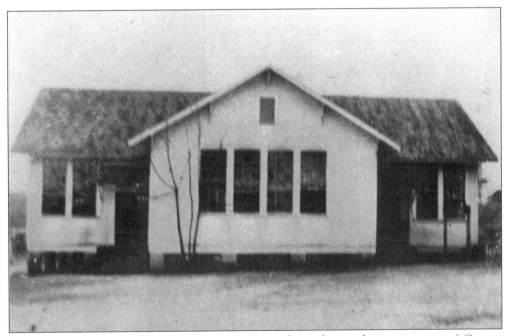

FAIRVIEW SCHOOL C. 1936. Fairview School was located near the intersection of County Roads 36 and 49. (Courtesy of Faye Barnes and Nannie South.)

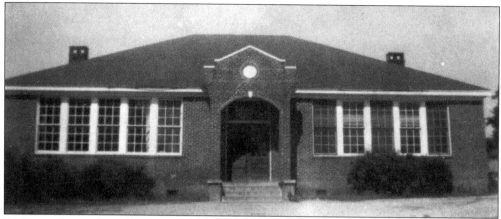

FAIRVIEW SCHOOL, BUILT 1938–1939. The women in the community took an active role in helping the school, performing such tasks as canning food to be used for lunches. Anything that needed to be done, the mothers of the pupils were always ready to help. (Courtesy Faye Barnes and Nannie South.)

FAIRVIEW SCHOOL BALL TEAM, 1936–1937. Members of the team included the following, from left to right: (front row) Henry Omary, J.B. Lee, Clyde Flynn, Delton Trimm, Billy Christian, Golden Sizemore, J.T. Christian, Robert Miles, and Edwin Black; (back row) Kenneth Rector, Waymon Benton, Milner Anderson, James O. Erwin, Johnnie South, William Sizemore, Dexter Morrision, Earnest South, Charles McPherson Jr., Lyneer Morgan, and Walter Burnett. (Courtesy of Nannie South.)

FAIRVIEW SCHOOL, 1946. The students in this photo are, from left to right, (front row) Brooks Barnes, Everett South, John South, Gary Sizemore, Bobby Joe Black, Billy Wayne Smith, and Max Burnett; (back row) Louise Smith, Ruth Brown, Barbara South, Marllene Newcomb, Robbie Gray Hollis, Mildred Smith, and B.J. Lucas.(Courtesy of Faye Barnes.)

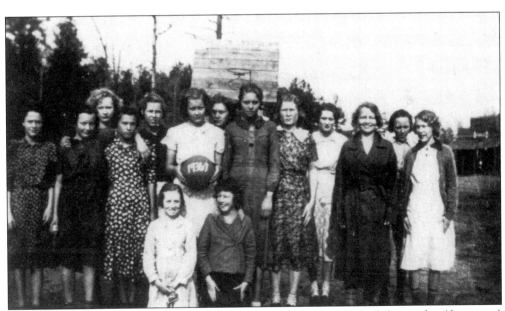

FAIRVIEW GIRLS BALL TEAM, 1936. The team members were, from left to right, (front row) Edwina South, and ? Thomas; (middle row) Lavelle Burnett, Julette McPherson, Mary Frances Franks, Allie Smith, Alice Smith, Edith Black, Elridge Recter, and Dovis Flynn; (back row) Ruby Flynn, Ruby Gray Gosa, Doffie Benton, Lily Smith, and Ruth Mae Black.(Courtesy of Nannie South.)

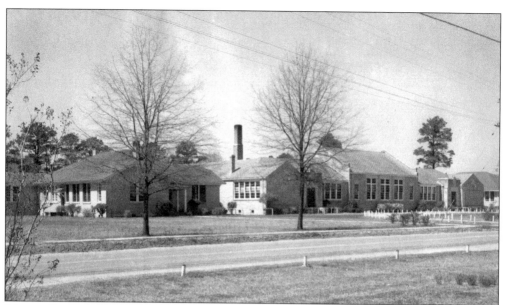

LAMAR COUNTY HIGH SCHOOL, 1950. Lamar County High School was built in 1936. The one-story buff brick building is still in use today, but a new building is being constructed. (Courtesy of Gene Cantrell.)

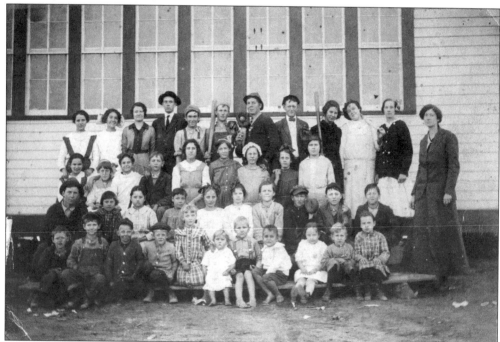

MAPLE SPRINGS SCHOOL, EARLY 1900s. Maple Springs School was located southwest of Vernon. Known to be in this picture are Tennel Ward, Fred Ward, Malone Brown, Beatrice Springfield, Claudie Springfield, Gary Springfield, Permelia Adair, Ruby Shelton, Susy Brown, Marie Springfield, Ozzie Ward, Lester Ward, Alma Ward, Geneva Brown, Hayes Livingston, Annie Lou Ward, Lillie Livingston, Albert Perkins, Harvey Ward, Fred Brown, Pearl Livingston, and Vannie McGill(teacher). (Courtesy of Marie Rowland.)

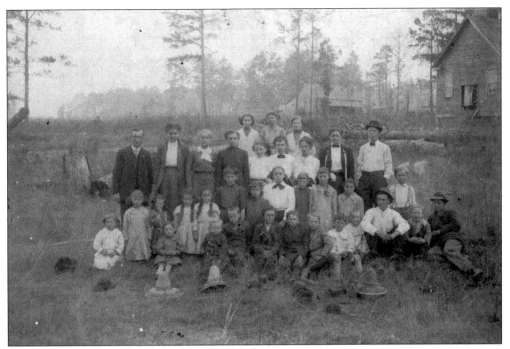

MULBERRY SPRINGS SCHOOL. Mulberry School, early 1900s, was located southeast of Sulligent. (Courtesy of Beulah Hill.)

MOLLOY SCHOOL, 1943. Seen in this photograph, from left to right, are (front row) Barbara Atkins, Robert Smith, Bobby Crossley, Harold Hopper, Billy Wayne Perkins, and ? Thompson; (back row) Jack Hayes, Billy Paul Crossley, Alice ?, Billy Ray Dees, John D. Allen, and Bobby Hopper. (Courtesy of Kay Koonce.)

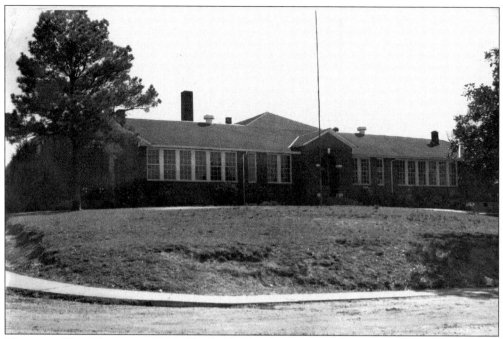

MILLPORT HIGH SCHOOL, 1950. This high school building was completed by the 1921-1922 school year. (Courtesy of Gene Cantrell.)

MILLPORT GIRLS BASKETBALL TEAM, 1925. Basketball was played in the school auditorium until the gymnasium was erected. (Courtesy of L. Peyton Bobo.)

MILLPORT SENIOR III CLASS 1931–1932. School buses were first used to transport pupils to Millport in 1927. F.V. Kurkendall (back row, far right) was the principal. (Courtesy of L. Peyton Bobo.)

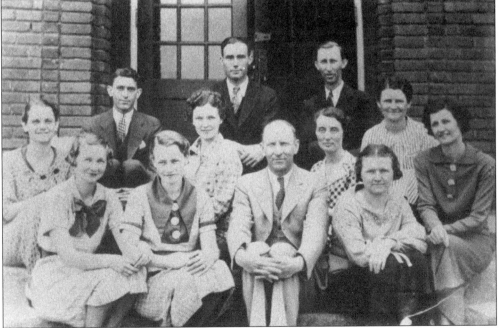

MILLPORT SCHOOL TEACHERS C. 1924. F.V. Kuvkendall is pictured third from the left. He resigned from Millport High School after serving as principal for 20 years. Ms. Ina Prater and Ms Coleman are known to be in the picture. (Courtesy of L. Peyton Bobo.)

OAK HILL SCHOOL MUSICAL. In 1933 Oak Hill School presented a musical entitled *Minuet in G*. Oak Hill School was located south of Sulligent. (Courtesy of Theresa Chandler.)

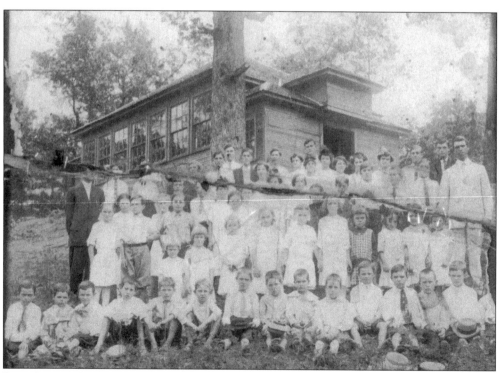

PINE SPRING SCHOOL, EARLY 1900S. Burlin Norton is ninth from the left on the front row. Pine Springs School was located north of Sulligent. (Courtesy of Burlin Norton .)

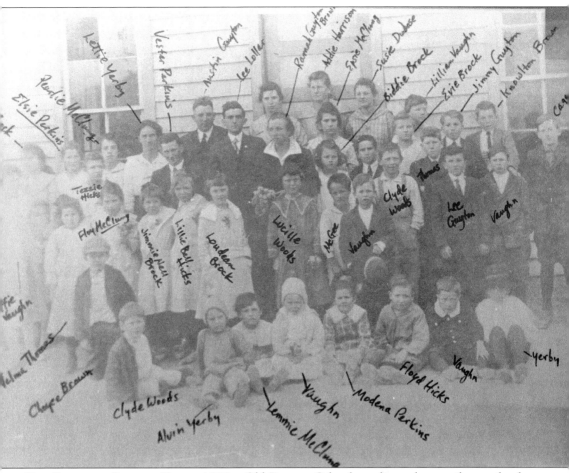

OLD PROGRESS SCHOOL, EARLY 1900s. Old Progress School was located two miles north of Crossville. (Courtesy of Loree Christian.)

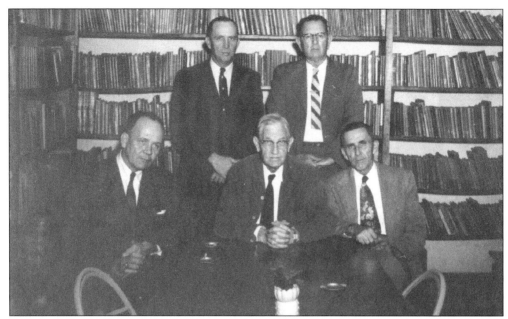

LAMAR COUNTY SCHOOL BOARD. Pictured in the early 1950s are members of the Lamar County Board of Education. From left to right are as follows: (seated) Young Shelton, Felix Sizemore, and Benton Hankins; (standing) J.C. McAdams and Vance Johnson. (Courtesy of Theresa Chandler.)

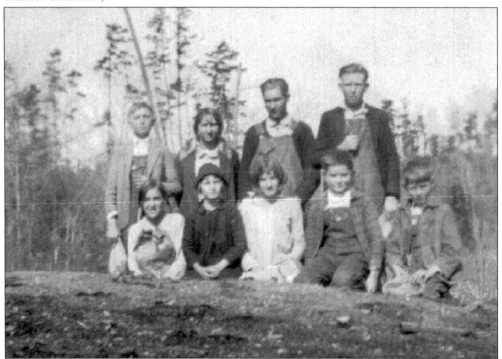

SHILOH NORTH SCHOOL, 1929–1930. Pictured from left to right are (front row) Louise King, ? Cantrell, and two unidentified; (back row) Clay King, Girl Blaylock, Boy Blaylock, and Carl King.

**SHILOH NORTH TEACHERS,
1929–1930.** Birdie Lee LeDuke (1905-
1996) is pictured on the left and Lucy
Grace Beasley is on the right. The two
women boarded with the Wash King
family while teaching school in the
community.

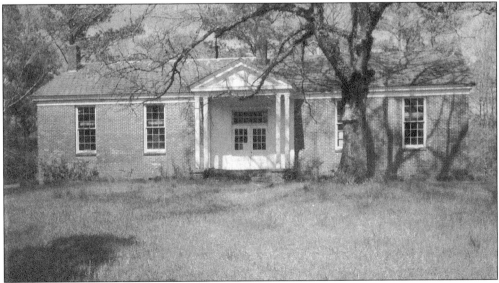

SPRING HILL SCHOOL. Spring Hill School was built about 1934 and is still standing today in
southwestern Lamar County near Millport. (Courtesy Lena Hawkins.)

87

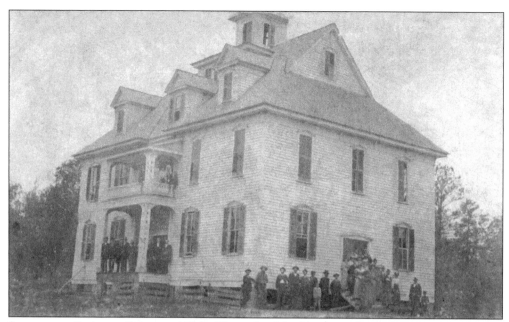

SULLIGENT SCHOOL, BURNED 1908. This school building was located on Evans Street in Sulligent near where Mrs. Mildred Boyett lives today. It is told the school burned when three boys were smoking and a pigeon nest in the belfry accidently caught fire. Pete Hollis, whose father was mayor, was involved. (Courtesy of Gail Evans and Kay Evans.)

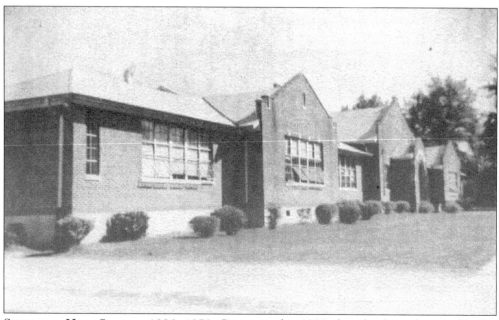

SULLIGENT HIGH SCHOOL, 1930–1973. Constructed in 1930, the school was destroyed by fire in 1973.

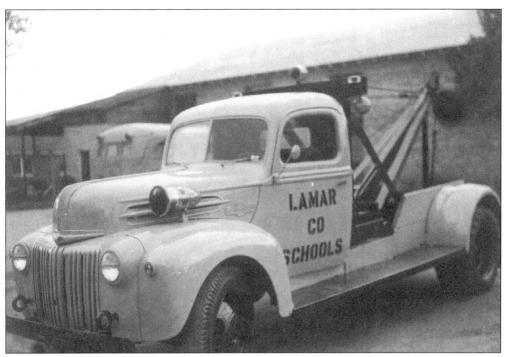

LAMAR COUNTY SCHOOL WRECKER. This photo was probably made in the early 1950s. (Courtesy Theresa Chandler.)

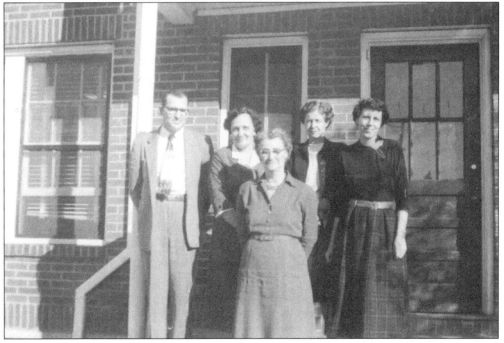

SUPERINTENDENT CHANDLER AND GROUP. Lena Woods is pictured in front and on the back row, from left to right, are A.A. Chandler, Annie Grey Smith, Supervisor Ruth Shackelford, and Nell Holley. (Courtesy Theresa Chandler.)

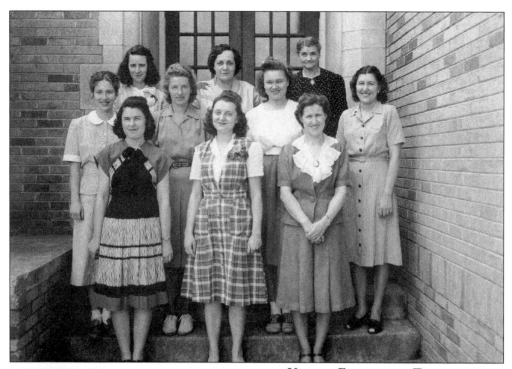

VERNON ELEMENTARY TEACHERS, LATE 1940S. Pictured from left to right are (front row) Captolia Pratt, Betty Ruth Brock, and Adine Gilmer; (middle row) Bobbie Odem, Blondie Crawford, Ordelia McGee, and Theresa Reeves; (back row) Raye Hayes, Annie Grey Smith, and Annie King. (Courtesy Theresa Chandler.)

WOFFORD SCHOOL, 1942. Kawatha Chandler (left) and Wynette Norton are pictured standing near the Wofford School. (Courtesy of Kay Koonce.)

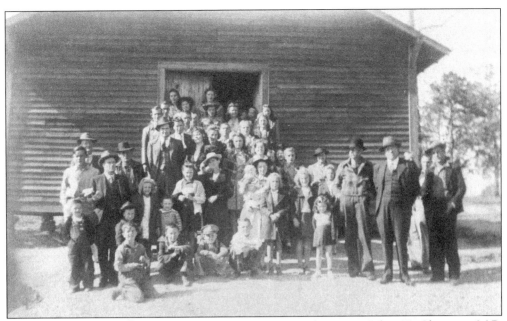

FAIRVIEW BAPTIST CHURCH. Some of the charter members were John. T. Christian, M.P. Poore, D.M. Sizemore, J.F. Steward, and C.D. Steward. A deed to the church grounds was obtained from Joel Reed in 1909. (Courtesy Loree Christian and Nannie South.)

FAIRVIEW BAPTIST SUNDAY SCHOOL CLASS IN 1948. Seen here from left to right are Charles Olen Christian, Billy Rodgers Christian, Charlene South, Louis South, Marilyn Christian, and Danny Paul Christian. (Courtesy of Nannie South.)

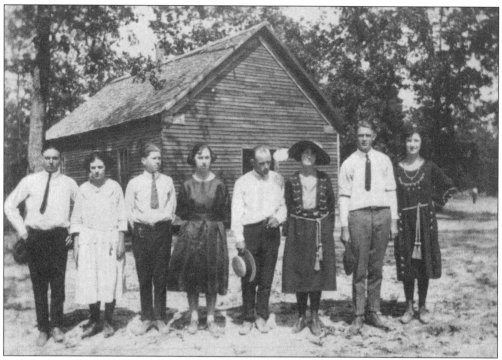

OLD LIBERTY FREEWILL BAPTIST CHURCH. Pictured at the church, from left to right, are Verdo Dubose, Epsie McClung, Clydie Woods, Wilma Hankins, Foster Hankins, Eulene Laster, Redden Mixon, and Ommie Laster. This early 1900s church was located near Crossville. (Courtesy Loree Christian.)

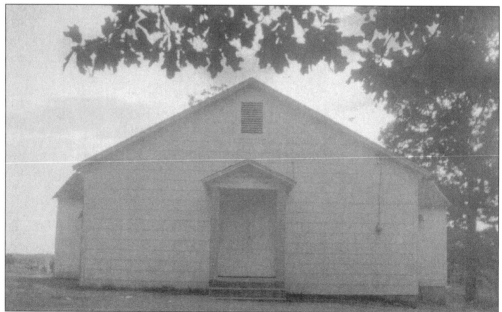

LIBERTY FREEWILL BAPTIST CHURCH, 1934. This building was constructed in 1934, about 40 feet from the present building. It was built from dressed lumber and painted white. (Courtesy of Loree Christian.)

MILLPORT CHURCH OF CHRIST, 1900. This building is thought to have been built around 1900, was torn down in 1954, and was replaced with a brick building. Some early members of the church were baptized in Driver's Creek. (Courtesy of Gene Cantrell.)

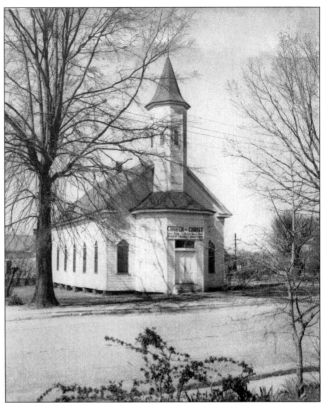

MILLPORT UNITED METHODIST CHURCH, 1955. The Millport Methodist Church was founded in 1888. The lot was bought from J.R. Selp for $40 on July 3, 1890. Justice of the Peace James Winston drew up the deed. (Courtesy of Gene Cantrell.)

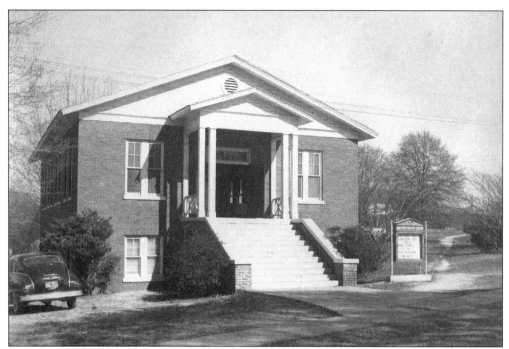

MILLPORT BAPTIST CHURCH, 1955. The Millport Baptist Church was organized July 25, 1887, with the following charter members: Lewis Blakney, Mrs. Rachel Blakney, Mrs. Annie A. Williams, Mrs. Sarah J. McAdams Stokes, Mrs. Emily Logan, and Josephine Morton. Rev. Judson Dunnaway was the first pastor. (Courtesy of Gene Cantrell.)

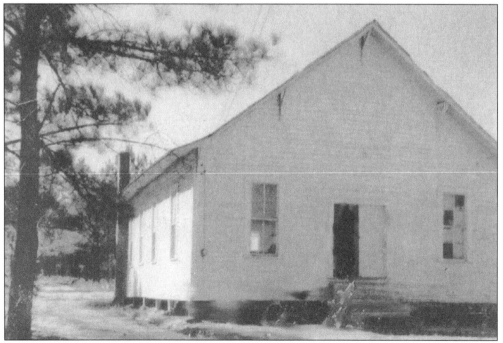

NEBO CHURCH, 1920–1921. The Old Nebo Church was destroyed by a tornado in 1920 or 1921. (Courtesy Kay Koonce.)

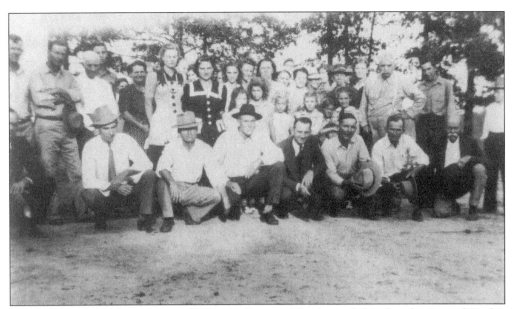

OAK HILL UNITED METHODIST CHURCH GROUP. Members of the church pictured in this photograph are, from left to right, (front row) Earl Reeves, Snowball Taylor, Guy Taylor, Tom Smith, Bro. Westbrooks, Harwood Thompson, Elzie Taylor, and Henry Reeves; (back row) Willie Reeves, Murray Taylor, Mac Pointer, Bessie Northam, Gladys Taylo (Snowball's wife), Gladys Taylor (Bart's daughter), Eunice Thompson, Faye Thompson, Christine Taylor, Peggy Reeves, Nobel Reeves, Cleo Thompson, Mary Nan Reeves, Samps Thompson, Gene Reeves, and Calvin Taylor. (Courtesy of Theresa Chandler.)

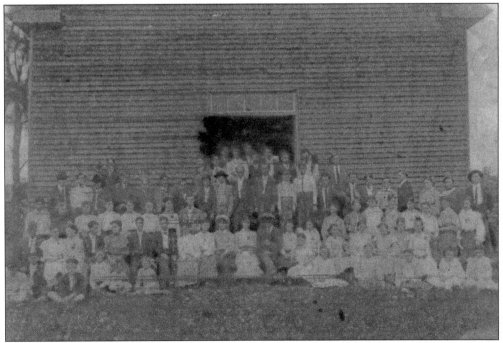

SPRINGFIELD FREEWILL BAPTIST CHURCH, EARLY 1900s. Organized in the 1860s, the church was located four miles west of Vernon off the Aberdeen road. (Courtesy of Kay Koonce.)

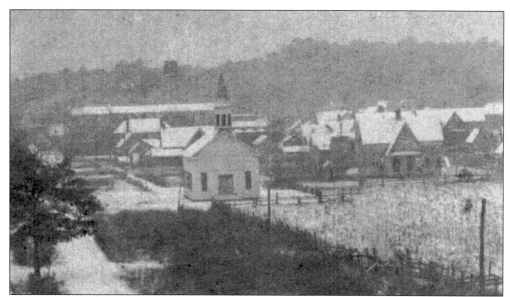

SULLIGENT FIRST BAPTIST CHURCH. Sulligent First Baptist began in 1890, with the following charter members: Mr. and Mrs. S.F. Pennington, Mr. and Mrs. A.L. Guin, L.D. Byrd, J.W. Presley, Mr. and Mrs. L.E. Langston, and Mrs. Polly Holliday. (Courtesy of Nell Priddy.)

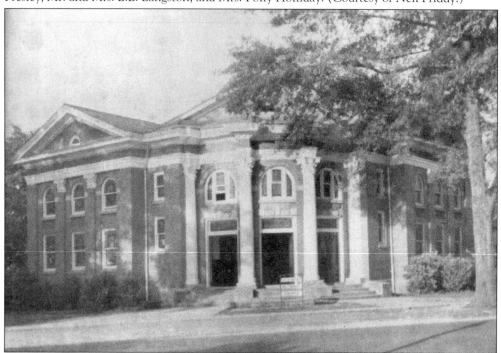

SULLIGENT UNITED METHODIST CHURCH. In 1888, Sulligent United Methodist Church was organized with the first members being founders of the town of Sulligent, and many of them being former members of the Methodist church at Cansler (a small community two miles south of Sulligent). Among the first members were the following families: Redden, Ogden, Brown, Bankhead, Guyton, Hollis, Cobb, Stone, Rush, Malloy, Priddy, and Guthrie. (Courtesy of W.W. Ogden II.)

SULLIGENT METHODIST SUNDAY SCHOOL CLASS. The two boys on the front row are W.W. Ogden II (left) and Knowlton Hollis. Mrs. Lois Hollis is behind the boys. (Courtesy of W.W. Ogden II.)

VERNON UNITED METHODIST CHURCH. This building was constructed around 1937. Members of the building committee were T.G. Roberts, D.D. Redus, G.S. Smith, and O.E. Young Sr. (Courtesy Gene Cantrell.)

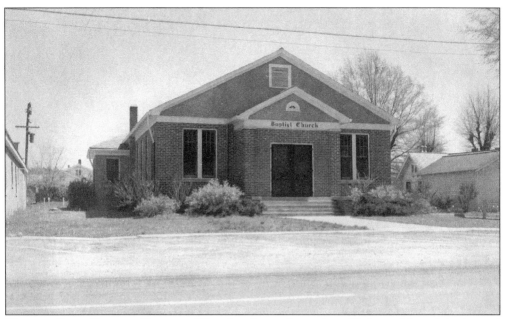

VERNON FIRST BAPTIST CHURCH. The church was located on Highway 17, and is pictured here in the 1950s. (Courtesy of Gene Cantrell.)

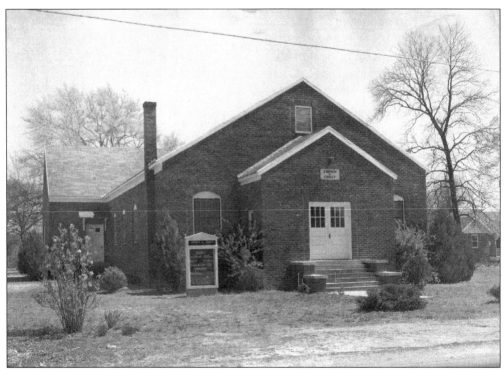

VERNON CHURCH OF CHRIST. This building was constructed in the late 1940s, and is pictured here in the 1950s. First Elders were J.A. Johnson, Bradley Wheeler, Raymond Bostick, and Luther Randolph. (Courtesy of Gene Cantrell.)

Five

HOUSES OF ROLLING HILLS AND BOTTOMLANDS

DR. W.L. BOX HOUSE. The home of Dr. William Lyles and Josephine Woods Box was located in the Bedford Community near Vernon. (Courtesy of Sarah Jo Spearman.)

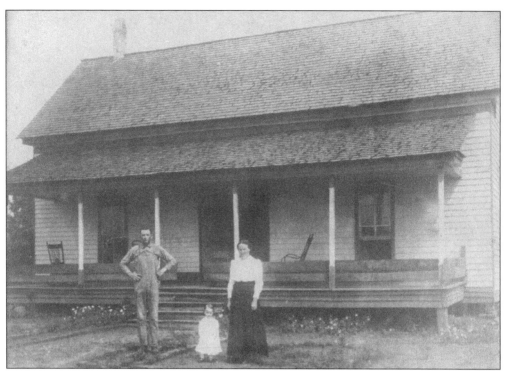

THE BEVERLY MOSE COLLIER HOUSE. This was the home of Beverly Mose and Sara Ann Nelson Collier. (Courtesy of Sarah Jo Spearman.)

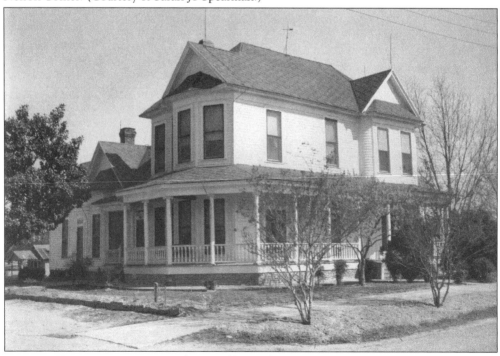

DOWDLE HOUSE IN MILLPORT. The Dowdle family home in Millport is used a funeral home today. It is seen here in the 1950s. (Courtesy of Gene Cantrell.)

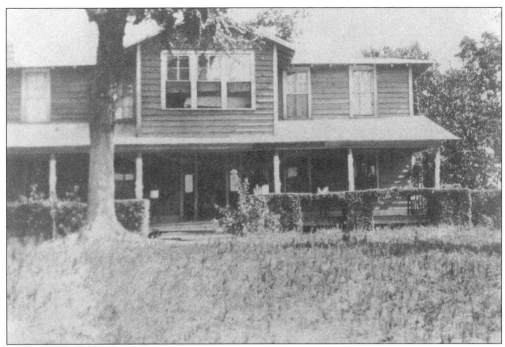

GEORGE GILMER HOUSE IN SHILOH. George and Lula Gilmer built this house around 1920, located in the Shiloh Community near Vernon. (Courtesy Mary K. Gilmer.)

GRAY GILMER HOUSE. Gray and Mary Gilmer built this house in 1953, when they returned to Gray's family farm after his parents died. Mrs. Gilmer lives there today. (Courtesy of Mary K. Gilmer.)

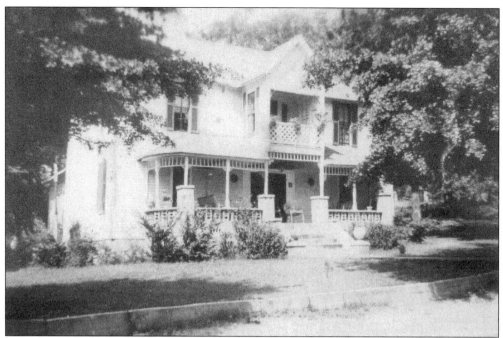

J.V. GILMER HOUSE. John Vandiver Gilmer built this house around 1900. It was located in the Shiloh Community, northwest of Vernon. (Courtesy of Virginia Gilmer.)

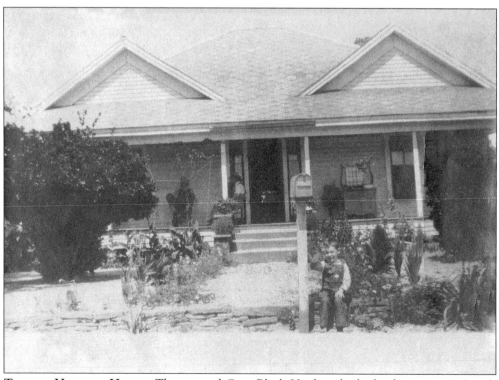

THOMAS HANKINS HOUSE. Thomas and Cora Black Hankins built this house in 1915 with local help. They paid $32 for windows and doors. (Courtesy of Loree Christian.)

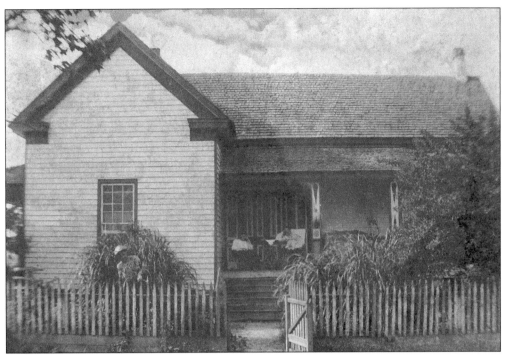

HODO HOUSE IN MILLPORT. The Hodo house in Millport is pictured in the early 1900s. (Courtesy L. Peyton Bobo.)

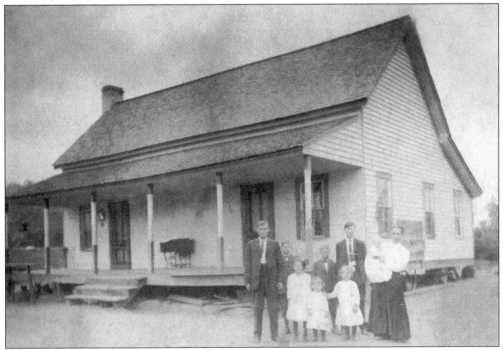

KING HOUSE ON LOST CREEK. The home (1915) of Wash and Sarah Evans King in the Lost Creek Community is seen in this photograph, with the following identified, from left to right: Wash, Clyde, Pearl, Lula Bell, Claude, Connie, Clarence, and Sarah (holding Carl).

MADDOX AND GIBBS HOUSES IN SULLIGENT. These homes are located on Highway 278 East. The brick house on the left was the home of Mr. and Mrs. Brooks Wells Maddox, and Mr. and Mrs. S. J. Gibbs lived in the white house. Mr. Gibbs, known as "Farmer," was an agriculture teacher at Sulligent High School. (Courtesy of Gene Cantrell.)

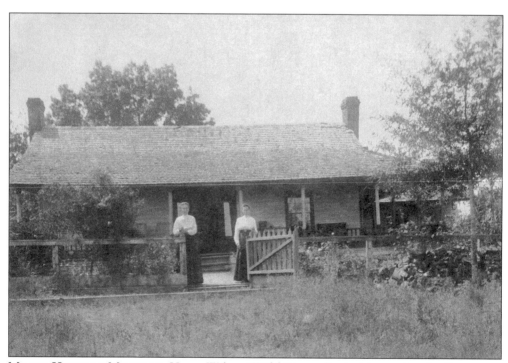

MILLER HOUSE IN MILLPORT. Henry Wilson "Wilsh" is credited with opening the first water-powered mill near Gentry Creek. His home is pictured here. (Courtesy L. Peyton Bobo.)

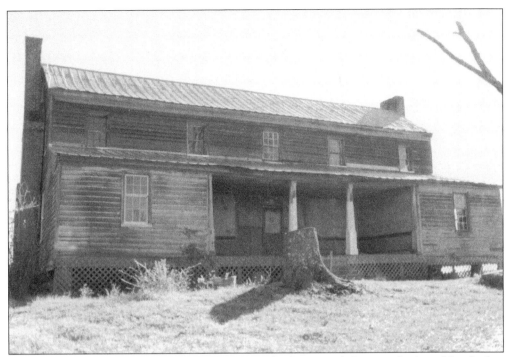

MOORE-HILL HOUSE. This house, also known as the Stagecoach Inn, was built and finished in 1834 for James Moore by Jesse Little Taylor, a carpenter and later a doctor. James Moore was a veteran of Andrew Jackson's Army. This house is located on a portion of Jackson's Military Road near Sulligent and is still in use today. This house was in the Hill family from December of 1881 until 1995. (Courtesy of Beulah Hill.)

BISHOP MARVIN NOE HOUSE. The home of Bishop Marvin and Gladys Young Noe was located between Detroit and Sulligent. (Courtesy of Mildred Boyett.)

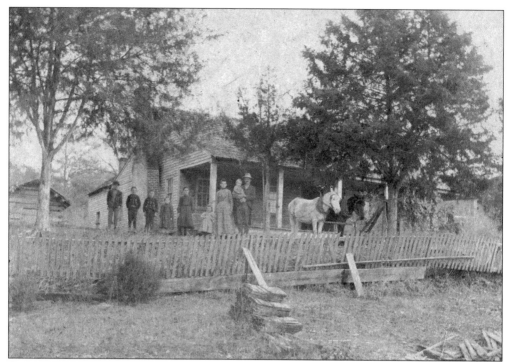

CLABORNE NOE HOUSE. The Claborne Noe home was located in the Pine Springs/Lost Creek area. (Courtesy of Dorothy Cleveland.)

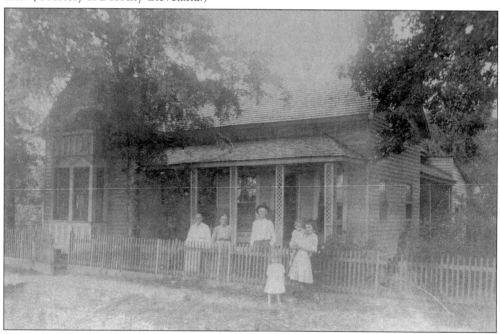

OLD OTTO PRIDDY HOUSE IN SULLIGENT. Known to be in this picture are Benjamin Murrah Molloy (1842-1918) and his wife Catherine Jane Cribbs Molloy (1844-1920). Benjamin Murrah was a veteran of the Civil War. Stratton Priddy was born in this house September 29, 1922. (Courtesy of Nell Priddy.)

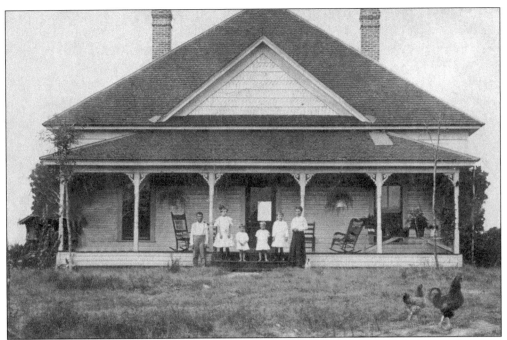

STRICKLAND HOUSE IN MILLPORT. This was the home of Peyton Bobo's grandparents. (Courtesy of L. Peyton Bobo.)

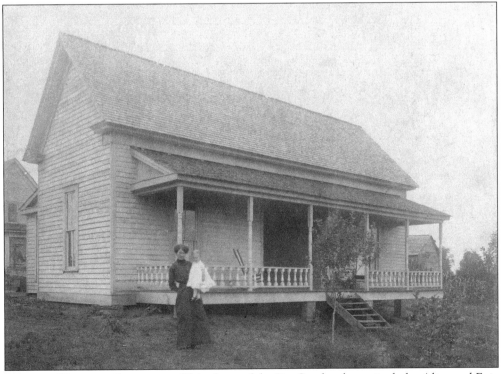

STUCKEY HOUSE IN SULLIGENT. This photo of the Jim Stuckey home includes Alice and Exie Stuckey. (Courtesy of Virginia S. Woods.)

TAGGART HOUSE NEAR VERNON. This is the first house of Jasper and Manerva Huff Taggart. It was built about 1854-1860, near Vernon. (Courtesy of Kay Koonce.)

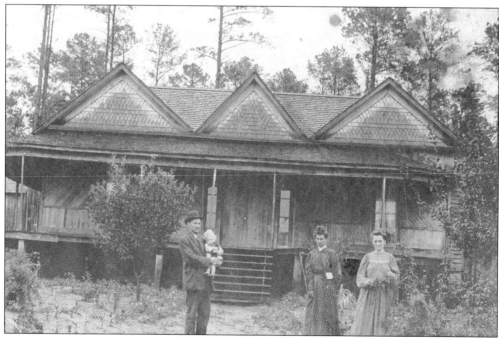

DR. BERRY EDLEY TURNER HOUSE. The home of Dr. Berry Edley Turner was located in the Sunnyside Community below Asbury Methodist Church down County Road 9. The house stood until the 1930s. (Courtesy of Betty Ruth Brock.)

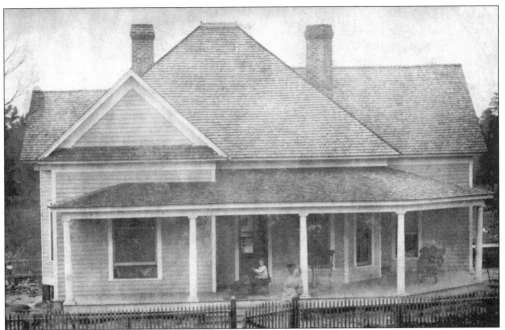

THE WHITE HOUSE IN DETROIT. This was the home of the White family before they moved to Sulligent. Built in the early 1900s, the house is owned today by Barry and Jenny Carruth. (Courtesy of Ruth Spruiel.)

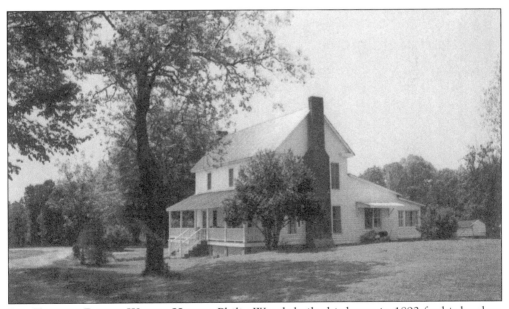

DR. THOMAS BAILEY WOODS HOUSE. Philip Woods built this home in 1892 for his brother, Dr. Thomas Bailey Woods, and his wife Elizabeth McCrary Woods. The couple moved here from Fayette County. (Courtesy of Virginia Gilmer.)

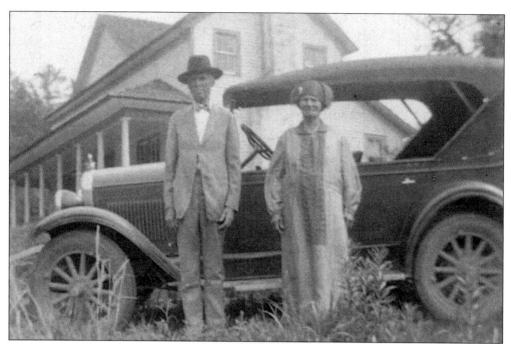

MILLER HOME PLACE. The old homeplace of William Billy Miller and Mary Ellen "Traylor" "Thomas" Miller and car (1920–1925).

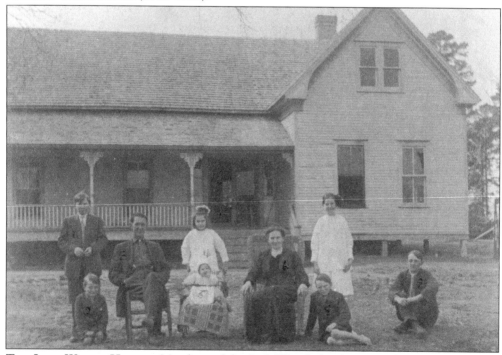

THE JACK WOODS HOUSE. Members of the Jack Woods family pictured at their home are, from left to right, Clark (tall boy on back), Thomas Clarence (small boy), Jack Wells Woods, Grace (standing behind baby), Christine (baby), Alice Woods, Flora (standing behind boy sitting), Prentiss (sitting in front of Flora), and Fred (at end). (Courtesy of Virginia S. Woods.)

Six

KINFOLKS AND
SUMMER COUSINS

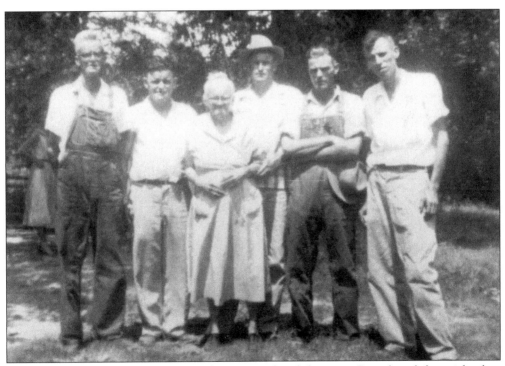

CARRUTH MEN. Emmer White Carruth is pictured with his sons. Seen from left to right they are Charlie, William, Emmer, Cecil, Earlie, and Dewey.

MOTHER AND SON. Nell Weeks Babb and her baby son, Gerald Babb, are seen here in 1955. Today Gerald is employed by the Lamar County Board of Education. (Courtesy of Sherrie Babb.)

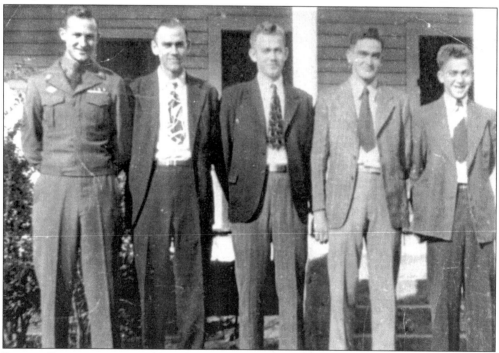

BOYETT BROTHERS. Pictured from left to right are Que, Dennis, Velmon, Ted, and Billy. The Boyett brothers were the sons of Lemuel Greene and Lula Ford Boyett. Each have contributed to our county in their own way. Que in the sawmilling and logging business, Dennis and Ted had a GMC Truck dealership in Sulligent; Ted was the Probate Judge of Lamar County, Velmon was a policeman at Sulligent and deputy sheriff, and Billy organized First State Bank of Lamar County. (Courtesy of Mildred Boyett.)

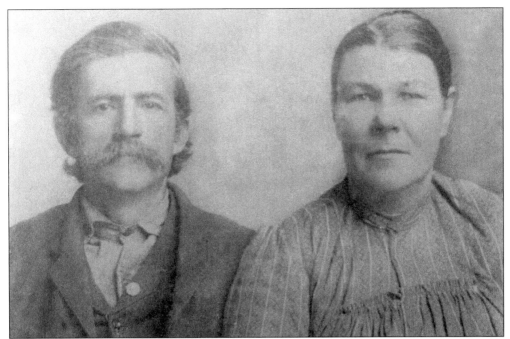

COUPLE MARRIED AT MILLER HOME. Robert Augusta Burnett (1855–1935) married Elizabeth Locinda Traylor (1875–1936) in October of 1875. Justice of the Peace Wiley Miles officiated the ceremony at the home of Samuel Miller. Robert was a farmer and Locinda was a midwife. (Courtesy of Faye Barnes.)

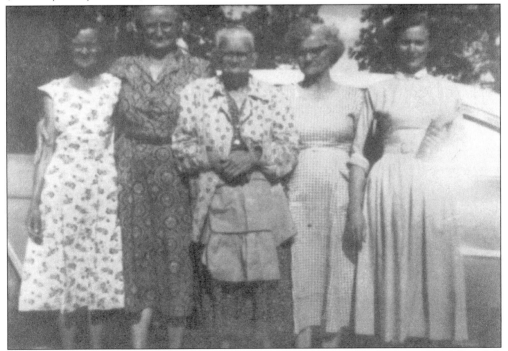

CARRUTH WOMEN. Emmer White Carruth is seen here with his daughters. Pictured from left to right are Crowlie, Ethel, Emmer, Loncie, and Millie Ray.

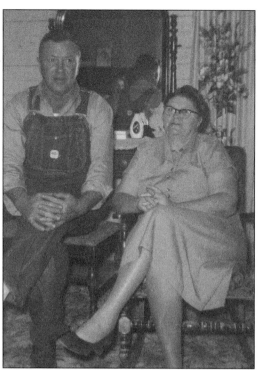

CRAWFORD COUPLE. Leonard Chester "Dan" and Rama Crawford of the Oakes Chapel Community were charter members of the Oakes Chapel Baptist Church. The church was organized in 1950 with 11 charter members. (Courtesy of Sheree Babb.)

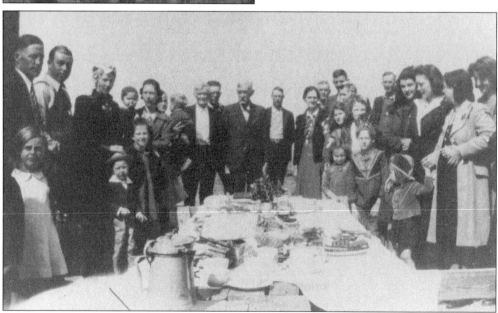

ELLIOTT FAMILY. Family members seen here, from left to right, are Mary Joyce Elliott, Luther Elliott, Grafton Oakes, Mae Oakes, James Edward Corbett, Bennie Corbett, Willie Quinn Corbett, Margie Corbett, Crowley Elliott, Charles Jr. Elliott, John Henry Elliot, Charlie Elliott, Bill Pennington, Walter Elliott, Virgie Elliott, Bud Lollar, Burris Clearman, Georgia Clearman, Wynelle Pennington, Jackie Pennington, Mary Nell ?, Jolene Lollar, Johnny V. Elliott, Jimmy Corbett, Eulelie Pennington, unidentified, Evelyn Oakes, Dovie Leigh, and Virginia Clearman. (Courtesy of Dianne Woods.)

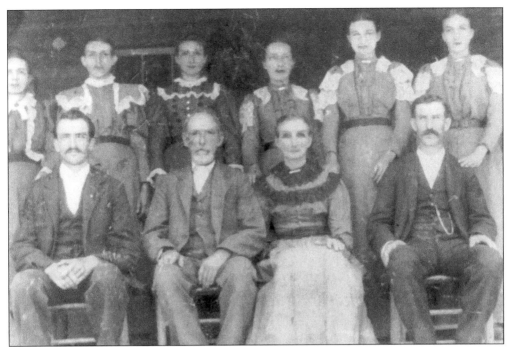

RICHARD GREEN EVANS AND NANCY ANN NOE FAMILY. Seen here from left to right are (front row) Green B., Richard Green, Nancy Ann, and William Thomas; (back row) Mary Jane, Martha, Rachel, Eliza Ann, Louella, and Sarah. This family lived in the Lost Creek Community, where Richard Green was a Justice of the Peace.

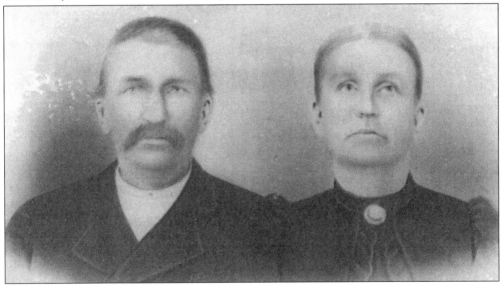

HUBERT AND SARAH ANN GUYTON HOLLIS. Hubert Hollis (1838–1904) was the son of Brunson Hollis. Sarah Ann "Sallie" Guyton (1840–1917) was the daughter of James F. and Sarah Guyton. Sallie claimed in her request for a widow's pension that Hubert served as a Private in Company H of the 10 Calvary. There was no record of his service with the War Department, but after several veterans swore they served with him she received a small pension. (Courtesy of Rex Hollis.)

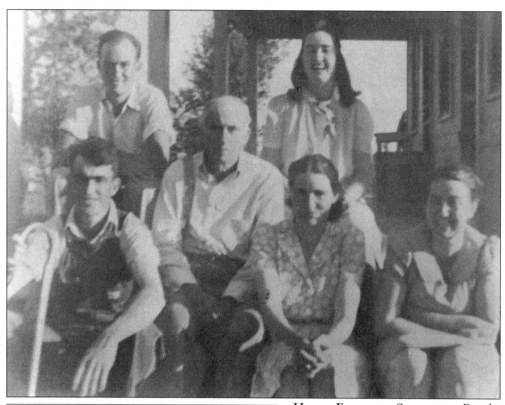

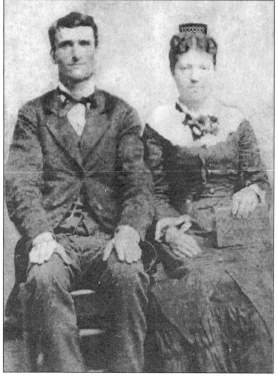

HOLLIS FAMILY OF SULLIGENT. Family members pictured here, from left to right, are (front row) James Franklin "Ned," James Lee "Toggie," Tommie, and Bessie; (back row) Robert "Bob" and Margaret Rebecca "Peggy." Toggie was the first-born son to Thomas C. Hollis. After his father's death, he returned home from Georgia to operate the family business. (Courtesy of Peggy Adair.)

DAVID AND LAURA THEODOSIA HUGHEY HOLLIS. This is believed to be David Hollis (1861–1938) and Laura Hughey's (1859–1928) wedding picture. They were married December 23, 1883. Laura was a schoolteacher. (Courtesy of Rex Hollis.)

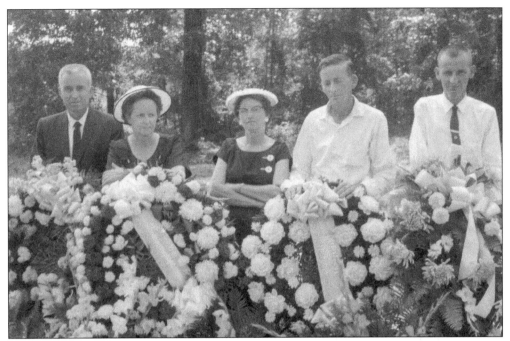

THE JACKSON FAMILY. Shown here from left to right are Braxton Brooks "Jack" Jackson, Ora Mae Jackson Reeves, Lennie Rae Jackson Nolen, Sessel Edward Jackson, and Johnny Arnold Jackson. This photo was made at Emmaus Cemetery near Vernon. (Courtesy of Sheree Babb.)

JACKSON COUPLE WED FOR 54 YEARS. Johnny Evans Jackson (1884–1961) and Nancy Carolyn Perkins (1894–1961) were married for 54 years. In 1961, Nancy Caroline died in August and Johnny Evans died in September. (Courtesy of Sheree Babb.)

DEWEY AND GENEVA LIVINGSTON. Dewey and Geneva Brown Livingston are pictured on their front porch, south of Vernon. (Courtesy of Marie Rowland.)

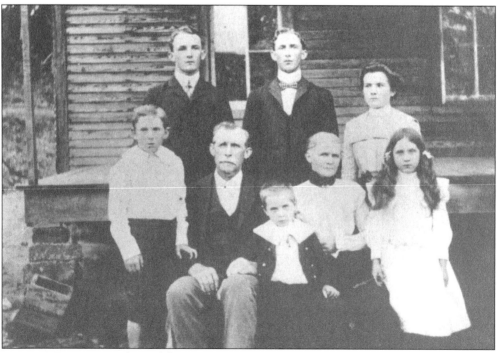

MADDOX FAMILY. Members of the James C. Maddox Family are, from left to right, (front row) Earnest, James C. Marvin, Sarah Frank, and Dezzie; (back row) Johnnie, Walter, and Minnie. (Courtesy of James Hill Maddox.)

LONGTIME MAYOR OF SULLIGENT.
William C. Maddox served as mayor
of Sulligent from 1918 to 1920 and
again from 1928 to 1952. He was
respected by all. His son James Hill
Maddox lives in Silligent today.
(Courtesy of James Hill Maddox.)

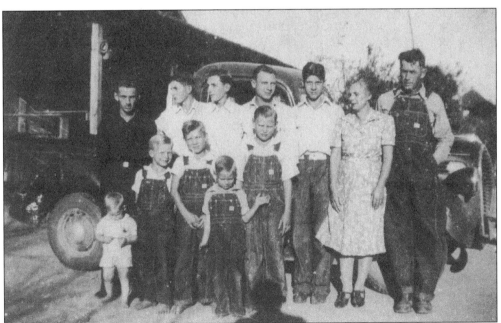

BRADLEY MCDANIEL FAMILY. The family of Bradley and Mittie Lee Thomas McDaniel
includes, from left to right, (front row) Glenn, Lyman G., Arval G., Cloyce, and Bryce; (back
row) Dennis, Leathel, Noel, Chelsie Ray, Clifton, Mittie Lee Thomas, and Bradley. (Courtesy
of Sammie L. Elliott.)

EDGAR MCDANIEL FAMILY. Shown in this photo, from left to right, are (front row) Lumie, Mary Lou, Jean, and Dezzie Rae; (back row) Monroe, Lionel, Jessie Banks, Loman, Bettie Sue, Leon, Edgar, and Sammie Lee.

MORDECAI SONS. Grady Richard and Ila Ridgeway Mordecai named their sons after Presidents of the United States. Pictured from left to right are (sitting) Warren Harding "Snowball" Mordecai and Grady Richard "G.R." Mordecai; (standing) Kelly Mordecai (half-brother to others), Woodrow Wilson "Buck" Mordecai, and Calvin Coolidge Mordecai. This family lived in the southern part of the county. (Courtesy of Lena Hawkins.)

MORDECAI FAMILY. On the porch of their house, still standing today on Fernbank Road, are: Harold Ray Rhodehamel, Warren Dale Mordecai, Rita Mae Mordecai, Billy Jack Mordecai, Patty Rhodehamel, Peggy Ann Mordecai, and Lena Sue Mordecai. Harold Ray and Patty Rhodehamel are cousins of the Mordecai family. (Courtesy of Lena Hawkins.)

VELMA VAIL MOUCHA. Velma Vail Moucha lived in the southern part of Lamar County. She lived in the old Spring Hill School building until she died. (Courtesy of Lena Hawkins.)

DAUGHTERS OF CLABORNE AND MATTIE NOE. Pictured are the daughters of Claiborne and Mattie Noe, (from left to right) Helen, Dorothy, Hester, and Hattie. They lived in the Pine Springs and Lost Creek area. (Courtesy of Dorothy Cleveland.)

SONS OF CLAIBORNE AND MATTIE NOE. Pictured are the sons of Claiborne and Mattie Noe of the Pine Springs and Lost Creek area. They are (from left to right) Sam, Rufus, Hubert, Earlie, Herman, and Willard. (Courtesy of Dorothy Cleveland.)

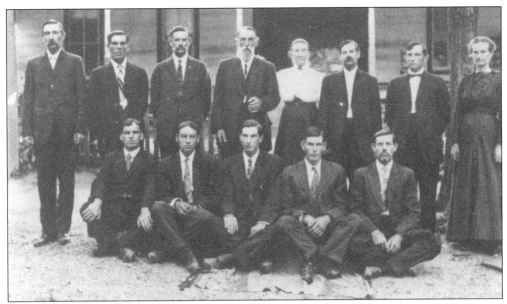

THOMAS NOE FAMILY. Family members include, from left to right, (sitting) S.W. "Sam" (1882–1928), Jessie C. (1884–1965), Major C. (1889–1942), B. Marvin (1893–1984), and William O. (1880–1965); (standing) John Clayton (1871–1942), James R. "Bob" (1876–1957), J. Dension "Den" (1870–1951), Thomas R. (1847–1936), Mary Jane (1849–1936), Benjamin Frank (1874–1957), Elisha Garrision (1878–1956), and Mary Elizabeth "Lizzy" (1887–1936). (Courtesy of Mildred Boyett.)

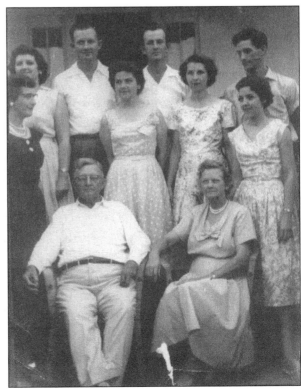

NORTON FAMILY OF PINE SPRINGS. Thomas Jesse Taylor Norton (1885–1958) and Mary Etta Turman (1895–1974) married in 1914. They lived in the Pine Springs Community. Their children were Madeline, Dorothy, George, Martha, Frances, Virginia, Roland, T.J. Jr., and Annie Mae. (Courtesy of Dorothy Northington.)

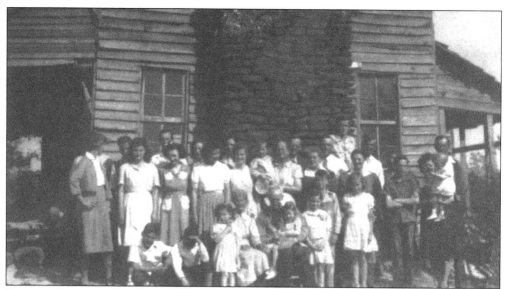

BURTON OAKES FAMILY. Seen here from left to right are (front row) Herbert Pennington, Billy Gartman, Martha Gartman (Langston), Martha Ann Graves Oakes, Burton Oakes, Jo Oakes (Curtis), Virginia Ann Pennington, Robert Pennington, and Vera Grace Oakes Elliott; (back row) Edd Gartman, Pearl O. Gartman, James P. Gartman, Eddye Pearl Gartman Cash, James Harry Gartman, Meredith Pennington Collins, Onnie Rhea Oakes (Wells), Jewel Oakes (Mauser), Evelyn Oakes, Johnny Wayne Pennington, Cassie Oakes Pennington, John W. Pennington, Artie Thomas Butler, Noah Butler, John Pennington Jr., Myrtle Lee Thomas Oakes, Murray Thomas Oakes, Mary Jane Oakes, J.C. Pennington, Loree Dubose Oakes, Dorothy Lee Oakes (Wilson), and Thomas Braxton Oakes. (Courtesy of Dianne Woods.)

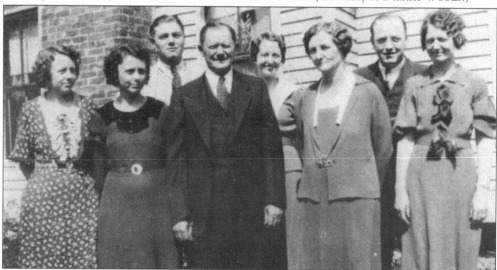

R.C. PAUL FAMILY. Members of the family include, from left to right, (front row) Ruby Gray Paul Faulkner, Eva Lee Paul Givens, Robert Carroll Paul, Lillie Pearl Byrd Paul, and Lizzy Dee Paul Bobo, (back row) Robert Byrd Paul, Zanna Paul Allen, and Victor Carroll Paul. This family belonged to Sulligent First Baptist before 1925. R.C. served as Lamar County Commissioner District Two and Victor Carroll served as Lamar County Probate Judge. (Courtesy of Billy Paul.)

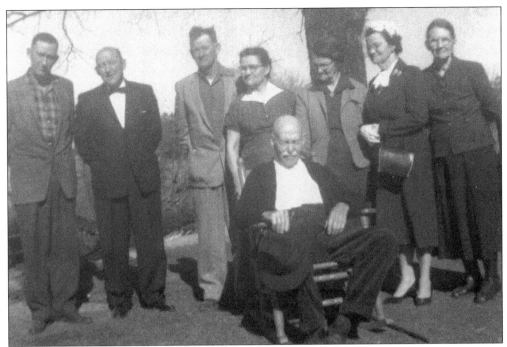

REEVES FAMILY NEAR SULLIGENT. Seated is Henry Reeves, and standing (from left to right) are Paul Reeves, Clay Reeves, Willie Reeves, Bessie Reeves Northam, Alice Reeves Stuckey, Bonnie Reeves Hill, and Ella Goodman. (Courtesy of Theresa Chandler.)

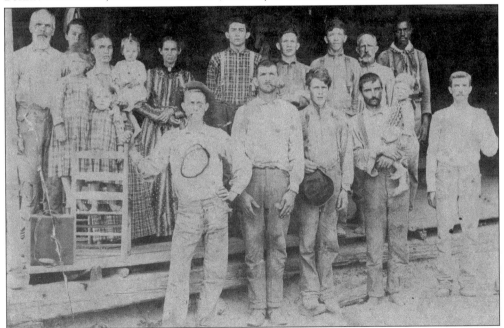

KEY THOMAS FAMILY. Known to be in this picture are Key Thomas, Ethel Graves, Ella Thomas and three of her children, Sally Thomas, Willie Butler, Newt Finch, Lee Hankins, Alson Finch, Claude Finch, Will Graves, and Clayburn Butler. (Courtesy of Evelyn Oakes and Diane Woods.)

THE SONS OF WALTER AND LONA MADDOX. From left to right are James Hill and Herman Maddox, the sons of Walter and Lona Maddox. They are shown here in 1927. (Courtesy of James Hill Maddox.)

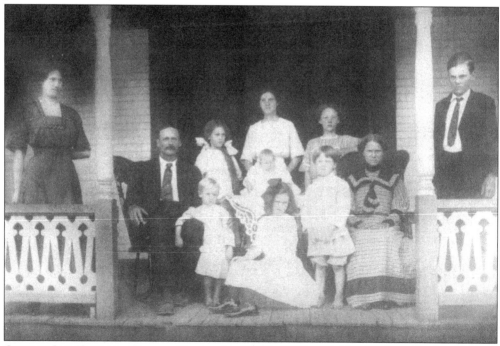

GEORGE JAY TURMAN FAMILY. George Jay (1871–1912) and Martha Ann Carden Turman (1871–1952) had the following children: Cora Lee, Flora, Mary Etta, Lee Roy, Fleda Pearl, Esther Mae, Bessie, George Dewey, Clyde Holland, and Fred Jay. All the children were born in Lamar County, and the family lived in the Pine Springs Community. (Courtesy of Dorothy Northington.)

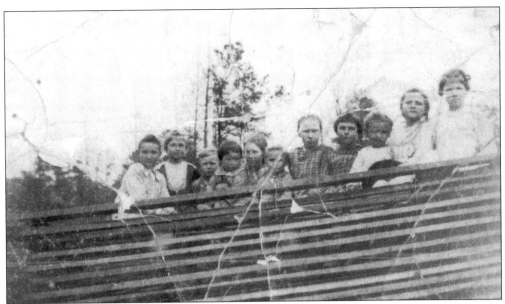

LOST CREEK FRIENDS. From left to right are Jewel Owens, Connie King, Carl King, Bertha Blaylock, Flora Blaylock, Clay King, Pearl King, Clara Bell Blaylock, Jessie Owen, and Lula Bell King.

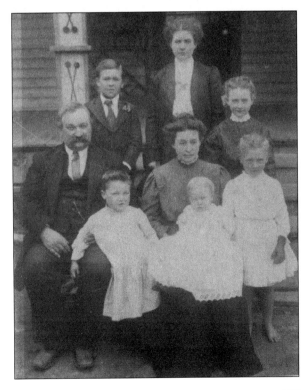

THE JIM AND MARGARET BUTLER WOODS FAMILY. Seen here from left to right are (front row) Jim, Virgie, Margaret, Belton (in Margaret's lap), and Betty; (back row) Philip, Frances (daughter of Jim and his second wife), and Leona. (Courtesy of Nannie South.)

KING COUPLE IN FRONT OF HOME. Willie Washington "Wash" and Sarah Evans King lived in the Lost Creek Community, and were known to many as "Uncle Wash" and "Aunt Sarah.". He was a farmer and owned a stave mill. Their home always had an open door to anyone with a need. They believed in their church and community, and supported both as long as they lived.

BOYS WILL BE BOYS. From left to right are the following: (front) Ugenia Mize, Della Mae Weeks, Estell Weeks, Sarah King, and Louise King; (back) Clay King and Carl King. It looks as if the boys stretched the cat out for the picture, and their mother doesn't know!

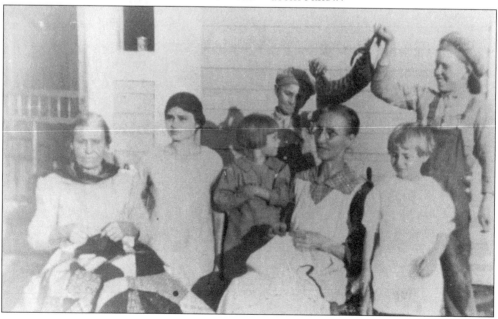